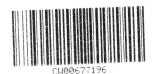

SIRHOWY VALLEY
THROUGH TIME
Ewart Smith

AMBERLEY PUBLISHING

Acknowledgements

Very many people have helped with the production of this book by making useful suggestions and furnishing me with information and old photographs. I would like to thank Mike Carey, Peter Downing, Brian Gardner, Doug Gilchrist, Dave McLain, Graham James, Richard Morgan, Selwyn Morgan, Bill Moses, Mike Perry, Cliff Sharp, Caryl Thomas, and Blackwood photographer Mike Yarnold.

In particular, I would like to thank John Watkins and my wife Betty for perusing the whole book and paying so much attention to detail.

This book is dedicated to my wife Betty
in grateful recognition of all her help and assistance.

First published 2010

Amberley Publishing Plc
Cirencester Road, Chalford,
Stroud, Gloucestershire, GL6 8PE

www.amberley-books.com

Copyright © Ewart Smith, 2010

The right of Ewart Smith to be identified as the
Author of this work has been asserted in accordance
with the Copyrights, Designs and Patents Act 1988.

ISBN 978 1 84868 743 1

British Library Cataloguing in Publication Data.
A catalogue record for this book is available from
the British Library.

Typeset in 9.5pt on 12pt Celeste.
Typesetting by Amberley Publishing.
Printed in the UK.

Introduction

Unbelievable change has taken place in the Sirhowy Valley over the last century. A society that was totally dependent on coal and steel has seen the closure of all its collieries, plus the steel works at Ebbw Vale. Commonplace sights have vanished. Before the advent of the colliery baths, scores of unwashed miners would wend their way home, where their first act was to bath. In my early years, we exchanged council houses with our next-door neighbours, whose breadwinner was a miner, because our bathroom was on the ground floor and theirs upstairs.

This book is an attempt to show, through photographs, how the valley has changed. As children, most of our free time was spent out-of-doors. There were so many open spaces where we could play football, cricket, or other games, and our parents believed we were safe. This is impossible today because the open areas have been built upon and the streets and car parks are too dangerous for young children to play in.

On the High Street, the small family businesses – the grocer, the baker, and the butcher, who sold us our provisions and delivered them – have all vanished. Other premises have disappeared – the electricity and gas showrooms, some of the Italian cafés, and many of the public houses. Charity shops, travel agents, building societies, and estate agents have replaced them. However, where the shop windows of yesteryear were frequently crammed to the gunnels, today we often see displays that make us stop and stare. For me, one difference that comes vividly to mind is how we get our meat. In earlier times, animals would arrive 'on the hoof', be slaughtered behind the High Street, then hang, in the open air, at the front of the butcher's shop, until the meat was sold. None of this would be countenanced today; most meat arrives in the supermarket pre-packed.

Buildings of years ago were often more interesting to look at. There were oriel windows, wood-panelled doors, finials on rooftops, and carved facia boards. Gardens were also good to look at, with their colourful displays of flowers. Today, the front garden is more likely to be the home of a caravan or motorcar.

There have, however, been many major improvements. The roads have been surfaced and are lit at night, fish thrive in the river, the dusty and unsightly spoil tips have disappeared, the horse does not leave its droppings on the road, and the telegraph wires have gone underground. On the downside, road signs have proliferated, there are road markings

everywhere, and in recent years bumps have been installed to impede the smooth flow of traffic – a consequence of the increase in the number of young, moneyed, overenthusiastic drivers.

Most people's perceived religious needs have changed too. Many Nonconformist churches and chapels have closed. Some have been converted into private houses, others into business premises, and in Blackwood the former Primitive Methodist Church is now the Little Theatre.

In the towns and villages of this valley, the centre of social activity was the Miners' Institute, paid for by deductions from miners' pay. Within their walls, one could read the national newspapers in the Reading Room, borrow books from the Library, play snooker, go dancing, or attend performances by the local operatic or drama society. To help us remember, the Oakdale Institute has been removed and rebuilt at the St Fagans National History Museum.

As you turn these pages, you will realise that some spots in the Sirhowy Valley are unrecognisable. Others show that little has changed beyond the application of a coat of paint. Some photographs may bring back memories while others will just make you feel satisfied to live among such friendly people in what is a truly stimulating part of the country.

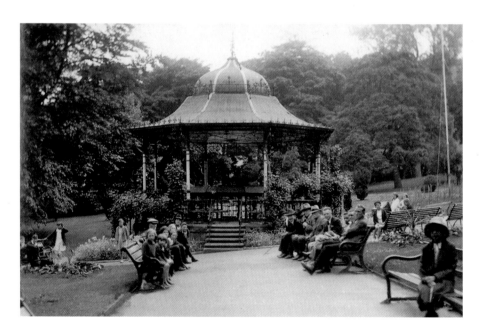

Bedwellty Park
The park was opened to the public in 1901. Over the years, its many facilities were significantly improved. In 1912, this bandstand was erected and in the summer months free concerts were given. It was recently refurbished, and the sound of sweet music can again be heard on various days during the summer.

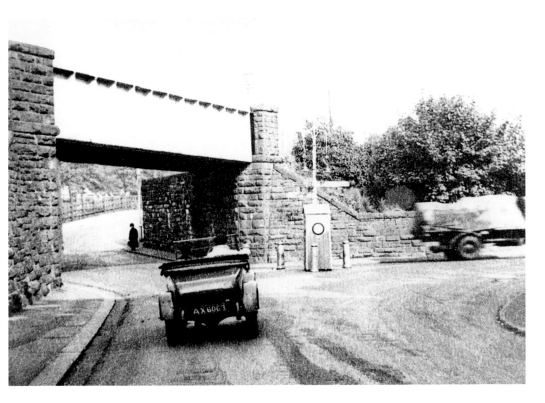

Sirhowy Bridge

This bridge was built to carry the Brecon and Merthyr railway line. In front stands a box in the middle of the road, possibly belonging to either the AA or RAC – or it may have been an ambulance box. The same viewpoint gives a completely different picture today. The technical institute was built on the ground just through the bridge on the left.

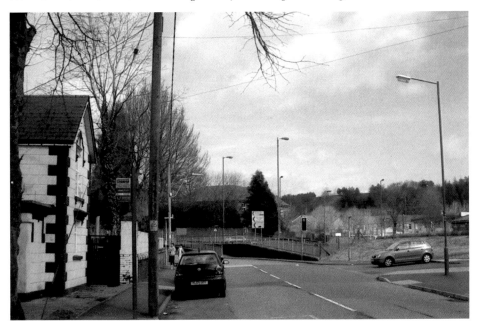

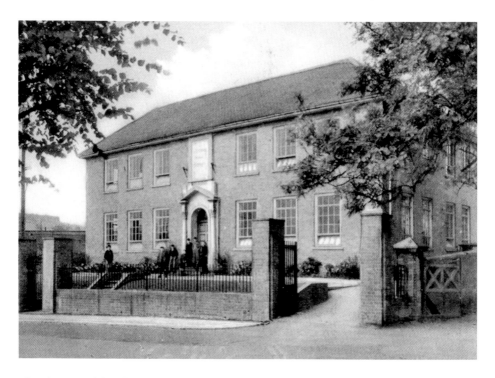

The Thomas Richards Mining and Technical Institute

The institute was opened in 1935 and so named to commemorate the life of Thomas Richards, miners' leader, Member of Parliament, Privy Councillor, former President of the Miners' Federation of Great Britain, and a Director of Ambulance for Wales. 'The Tech', as it became affectionately known, was absorbed into the comprehensive system in 1965 and is still used by Blaenau Gwent Council for educational purposes.

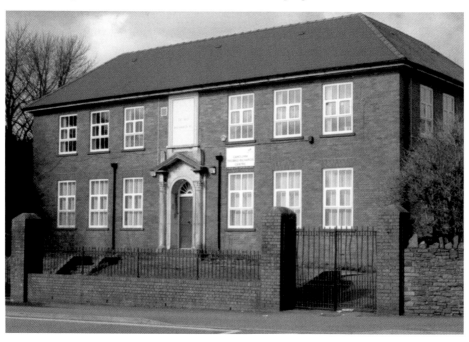

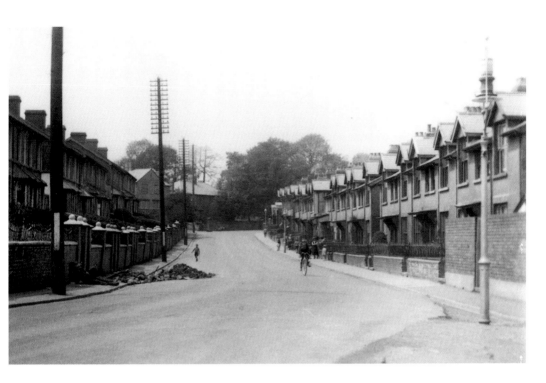

Ashvale, Tredegar

This photograph of Ashvale, built 1921-23, has three points of interest. Street lighting was by gas lamp, telephone wires were above ground, and a miner's free coal was dumped in the road for him to carry in (through the house!) after he had returned from a hard day's work. Cartref Aneurin Bevan, a residential home for the elderly, now stands at the end of the road.

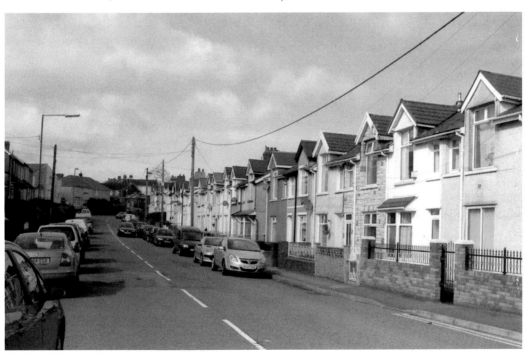

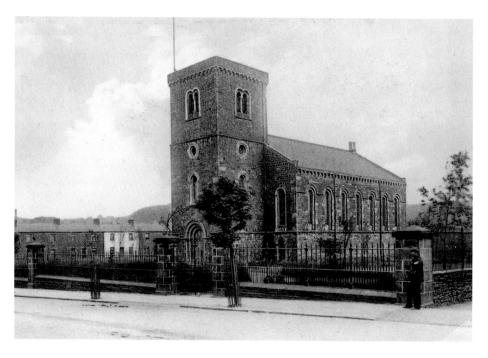

St George's Church, Tredegar
Consisting of chancel, nave, north porch and west tower, this church was built in the Norman style, cost £2,050, and was consecrated on 11 November 1836. A church dedicated to St George is rare in Wales, but it may have been so-named because Squire Homfray's son was called George – and the squire had led the negotiations with the Church Commissioners. At the other end of town, St James' was built in 1890. Both still have active congregations.

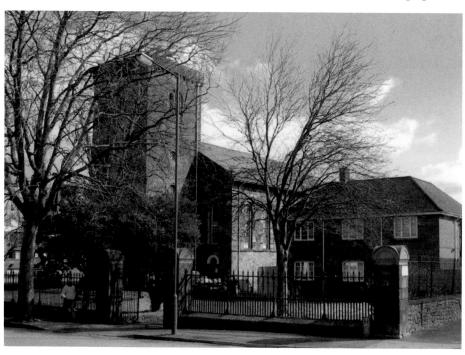

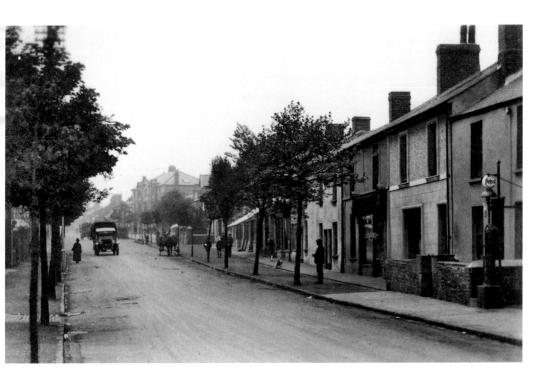

Church Street, Tredegar

These old properties in Church Street, which are shown on the Ordnance Survey map of 1837, are still in use. The photographs were taken looking towards the town centre. The large building in the distance is the former Central Surgery, built by the Tredegar Medical Aid and Sick Relief Fund. Aneurin Bevan, born in Tredegar, modelled the NHS on the fund.

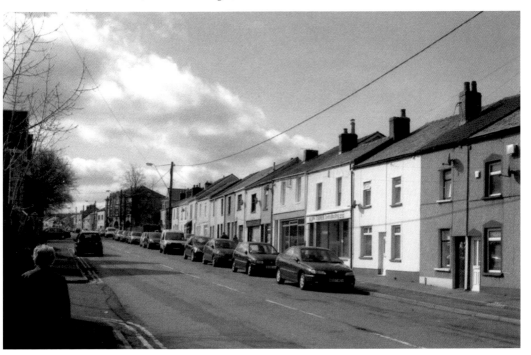

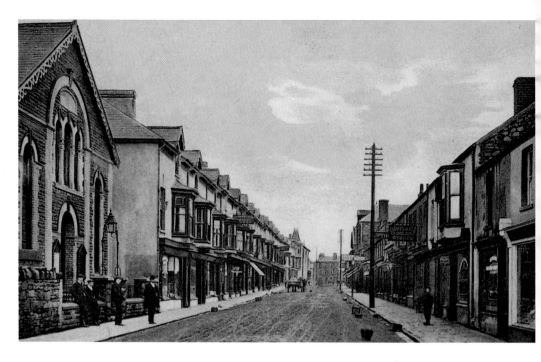

The Primitive Methodist Church, Tredegar

The Primitive Methodist Church is pictured on the left of Tredegar's Commercial Street. Belonging to a relatively small group of Nonconformists, the church was demolished in the early 1960s to create a route to the bus station, via the new Gwent Shopping Centre. Access for traffic is limited and restricted to entry from the other end of the street.

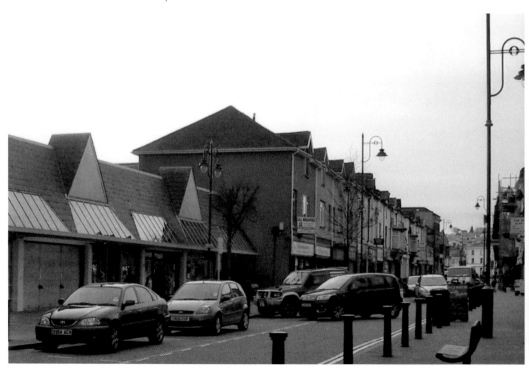

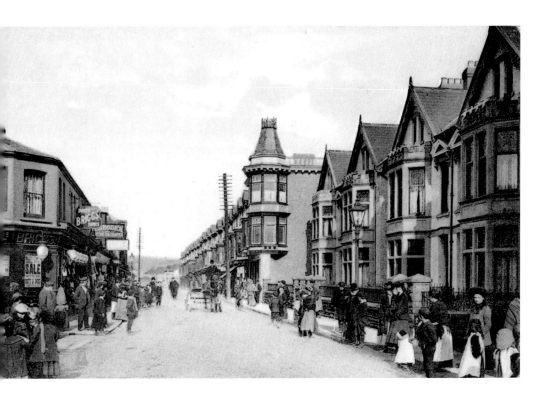

Commercial Street, Tredegar

In the 1920s, it was not unusual to see Commercial Street without a single motor vehicle in the road. The unusual oriel window of what is now the HSBC Bank has disappeared, as have the front views of the imposing bay-windowed houses with gardens. These were extended forward many decades ago to convert the houses into business premises.

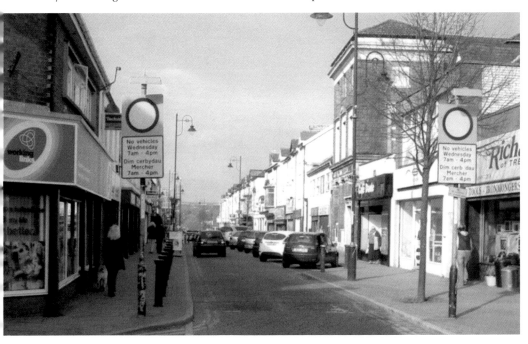

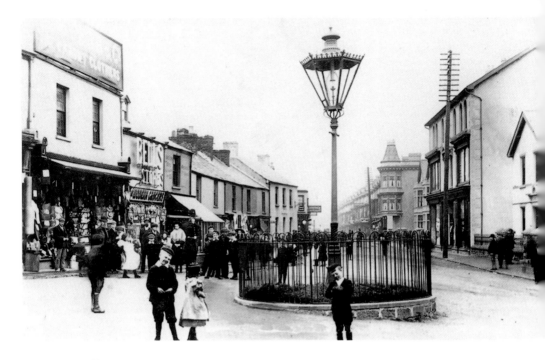

Diverting Traffic
At the top of Castle Street, the buildings on the right have now been removed to allow traffic to bypass Commercial Street and to provide access to the bus station.

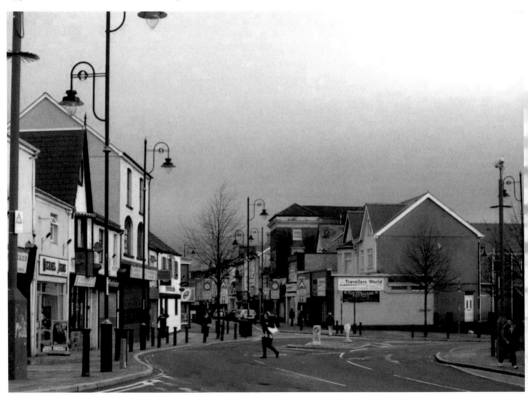

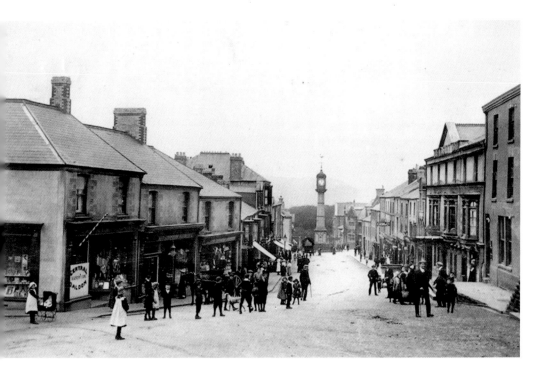

Castle Street, Tredegar
The town clock is in the distance. The pavement area, for pedestrian use, is now much increased, and the modern street lighting could easily be mistaken as Victorian. The Castle Hotel is on the right.

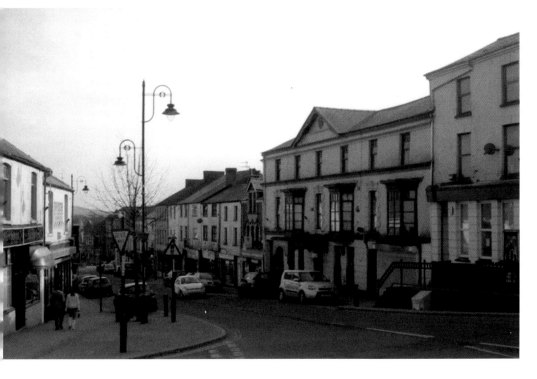

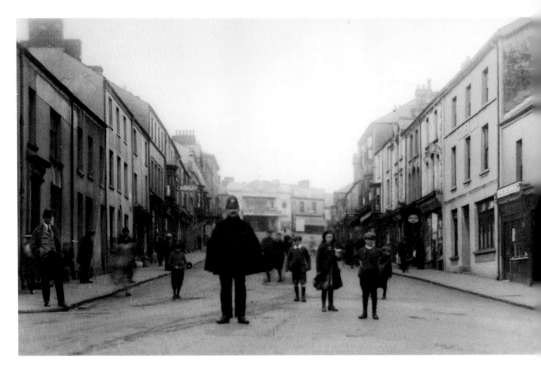

Toward the Queens Cinema
The strong arm of the law was once far more in evidence than it is today. Looking up Castle Street from the town clock, you can see the Queens Cinema in the distance. Variously a cinema, a roller-skating rink, and dance hall, it is now the Ironworks Bar & Gym.

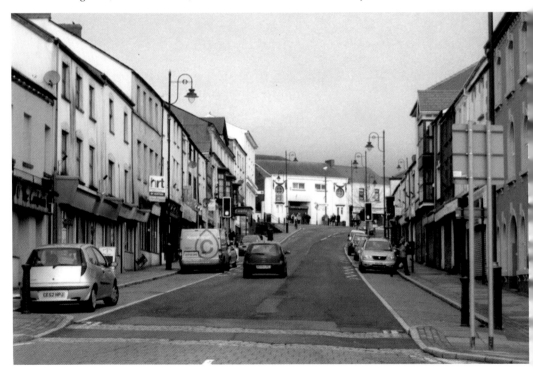

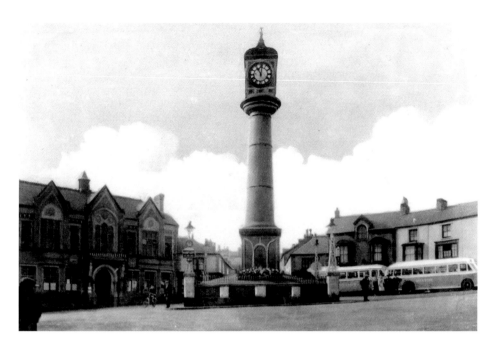

Tredegar Town Clock Viewed from the East
Erected in 1858 thanks to the enthusiasm of Mrs Mary Elizabeth Davies, wife of the Tredegar Company's general manager, this iron structure, whose clock chimes on the hour and half-hour, presents a face to each of the cardinal compass points. The sides of the base show the Duke of Wellington, the Royal Arms for England, Charles Jordan the iron founder, and a dedication to Mrs Davies. To the left is the old Town Hall and adjoining Market Hall, now the NCB Club.

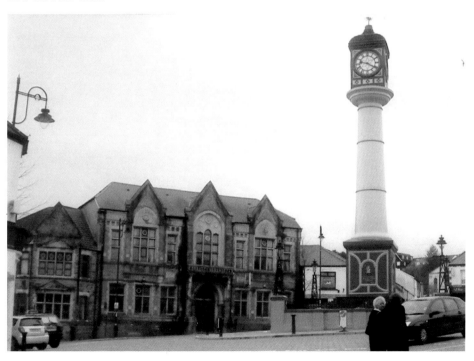

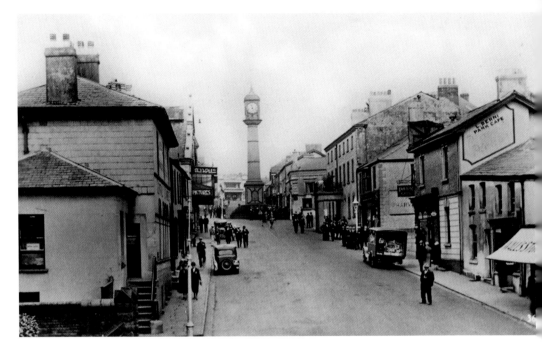

Morgan Street, Tredegar, Viewed from the South

What was once the Olympia cinema, near the clock on the left, is now a branch of J.D. Wetherspoon. Just out of shot on the right is the house where Michael Foot lived when, as the local MP from 1960 to 1992, he needed a base in the constituency.

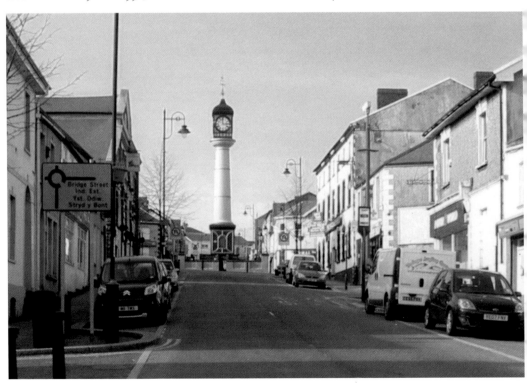

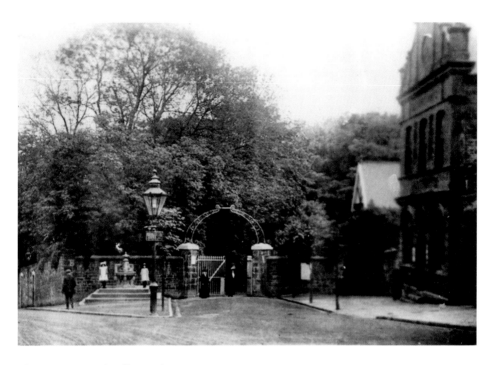

The Gates to Bedwellty Park

The park opened to the public in 1901. The Masonic Hall, opened in 1894 and extended in 1923, is to the right. St George's Lodge No. 1098, inaugurated in 1866, meets here. For many years the Post Office occupied the front of the building. In 1951, the original park gates were replaced by the Memorial Gates, which commemorate the lives of the men of the town who died during the Second World War.

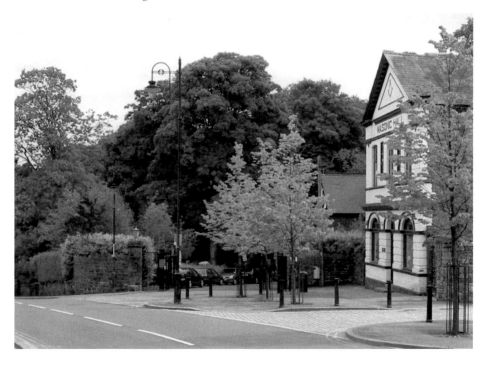

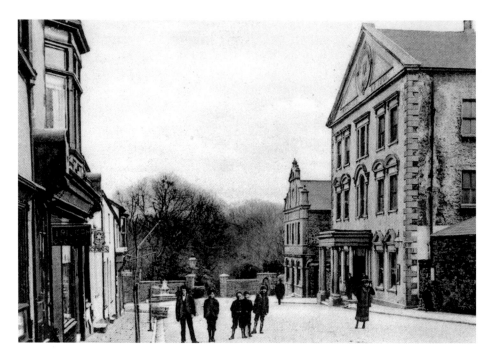

Temperance Hall, Tredegar

The building on the right was built for 'Entertainment, Instruction and Propagation of Temperance' in 1860-61 for around £2,500, in response to concern over the large number of workmen spending money in Tredegar's beer houses. It was used for Amateur Operatics and Amateur Dramatics. The Tredegar Workman's Institute bought the building in 1911. It was extended in 1931 and restructured to include a cinema and 'lesser hall' above the billiard hall. It was closed in 1982 and the site is now a car park.

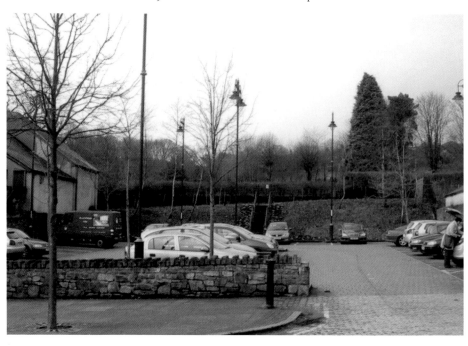

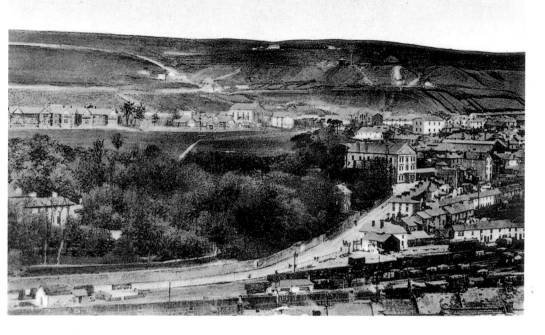

Bedwellty Park Viewed from the East

Bedwellty House, built in 1818 to be the home of the Homfray family, is on the left. The Cottage Hospital is some distance behind and Temperance Hall is to the right. Samuel Homfray was one of the co-founders of Tredegar Ironworks. Much of the industrial wasteland has now been cleared for housing.

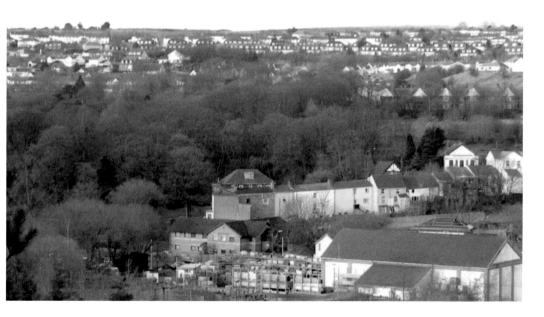

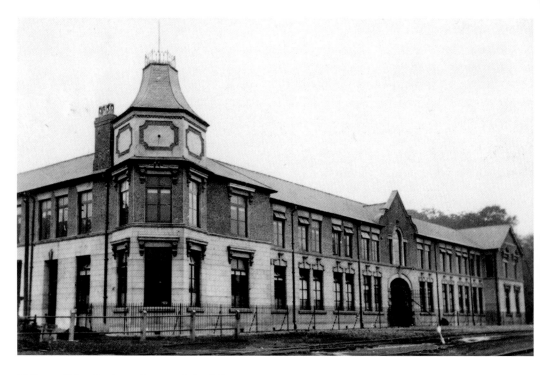

Offices of the Tredegar Iron and Coal Company
The Tredegar Iron and Coal Company was at first only the 'Tredegar Iron Company'. In fact, the town was frequently known as an 'Iron Town'. The company's name was changed in 1873 in recognition of its increasing coal interests, which numbered up to twenty collieries in the vicinity. In 1968, the offices were taken over by LCR Capacitors, but they were later destroyed by fire. Houses are now being built on the site.

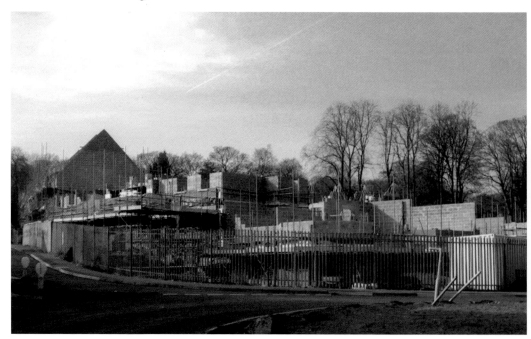

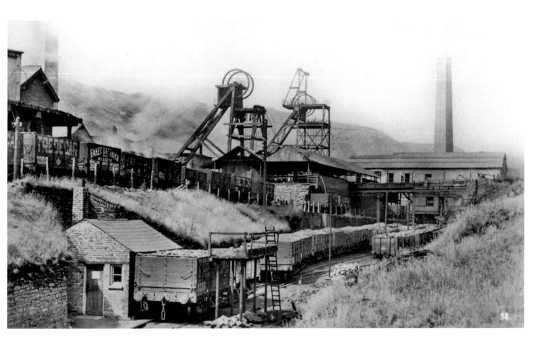

Ty Trist Colliery

Ty Trist ('house of sorrow') was the oldest colliery to be nationalised in 1947 and the only surviving colliery of the Tredegar Iron Company. Dating from 1834, and at one time employing 1,200 men, the colliery closed in 1959 and the site was soon levelled. When the grammar school, the technical school, and two secondary modern schools merged to form the county's first comprehensive school in 1965, it was an obvious choice of site. The long-awaited new buildings were completed in 1974, and a leisure centre soon followed.

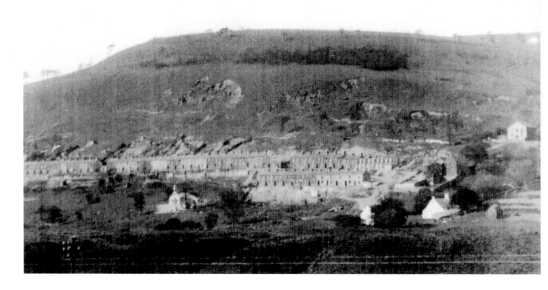

Troedrhiwgwair, *c.* 1906

In the 1900s, Troedrhiwgwair was a thriving village for the scores of miners who worked down the Pochin and Bedwellty pits. The village had its own school, post office, church, chapel, and public house. Today there are just thirteen families in as many houses. All the other buildings were demolished because the local council believed in the 1970s that there was risk of a landslide.

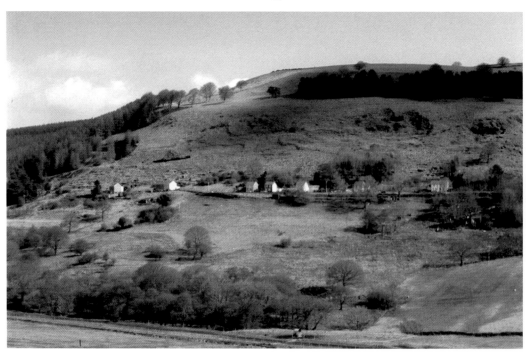

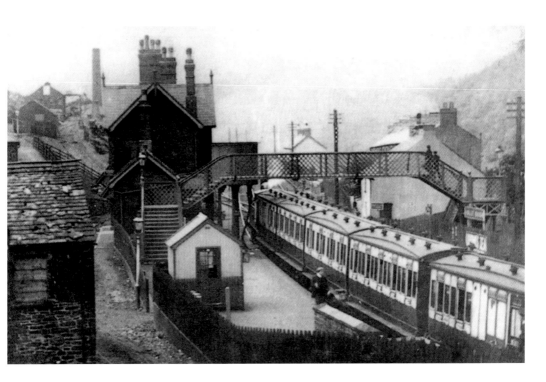

Hollybush Station

When this photograph was taken at the beginning of the last century, the principal way of travelling up and down the valley was by train. The more recent view is of the station building on the left (now a private house), taken from the opposite direction. The passenger service, which operated between Risca and Nantybwch, was withdrawn in 1960.

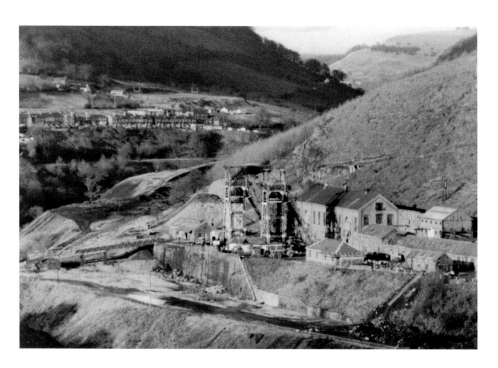

Markham Colliery Viewed from the South

You can see the village of Hollybush in the background. Named after a director of the Tredegar Iron Company, the colliery was opened in 1912. It was connected underground with nearby Oakdale colliery in 1979, and was closed in 1985. When the colliery opened, a miner's wage was about 25p a week, but a strike resulted in a minimum wage being introduced from 1914. At its height, more than a quarter of a million tons of coal were raised each year.

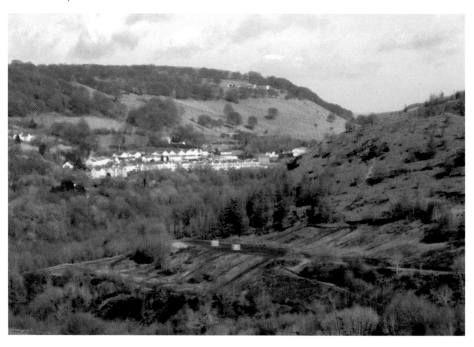

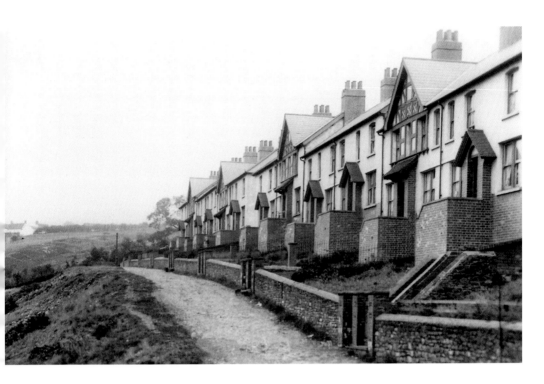

Markham Terrace, Markham

When they were built around 1930, these houses in Markham presented the occupants with a clear view across the valley. This is not the case today. On the plus side, they now have a footpath and a solid road surface.

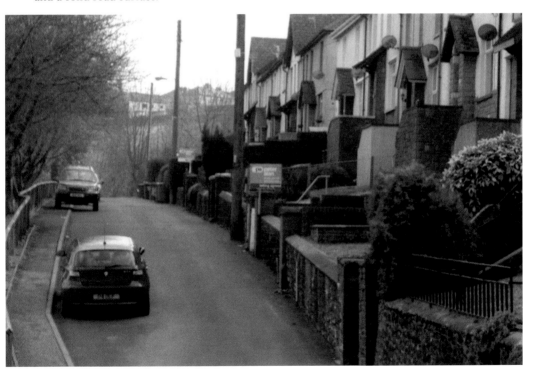

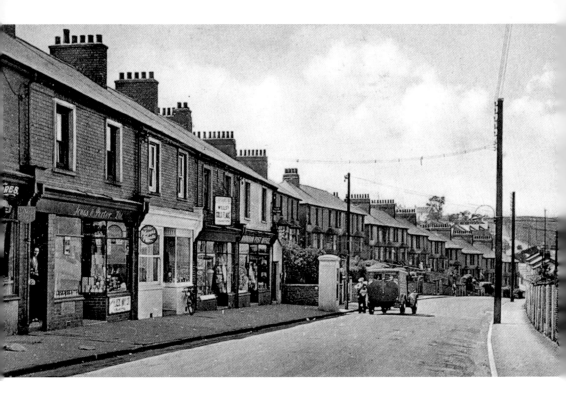

Abernant Road, Markham

This is the upper end of Abernant Road. Above, the village's shopping centre, including the Post Office, as it was in the early 1940s; below, how it is today. Little has changed – except that there is no longer a vibrant working colliery opposite.

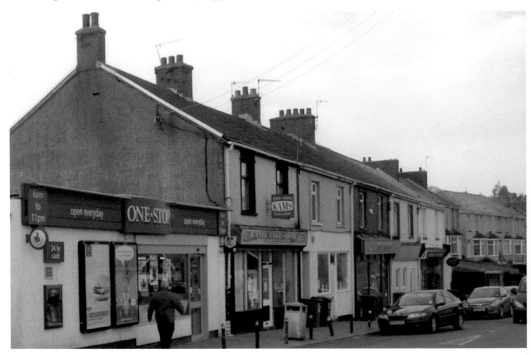

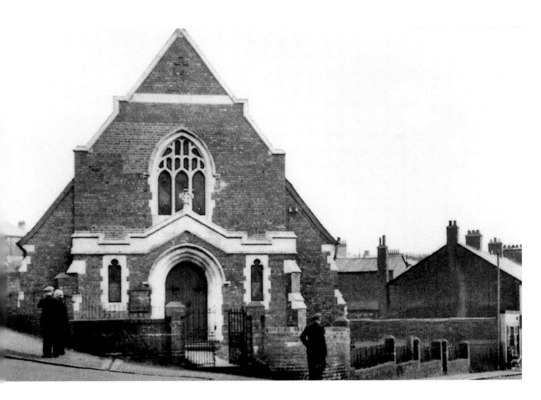

Markham Presbyterian Church

A grassy patch; a warning of speed bumps ahead. Today, no trace can be found of Markham Presbyterian Church, which stood on this site until the 1980s.

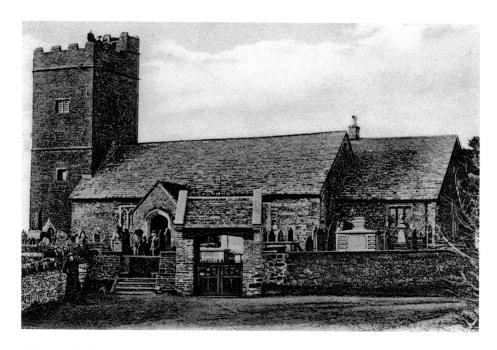

St Sannan's Church, Bedwellty

Sannan was an Irish contemporary of St David. Bedwellty's parish church dates from around 1220. In the early days, the church was white or limewashed, as can be determined by close inspection of its walls. During the major restoration of 2002/03, when the south aisle was re-roofed, the church once again became a white beacon on the skyline. The upper section of the fourteenth century embattled tower has not weathered well. The tower contains a peal of six bells dating from 1895, to which two were added in 1920.

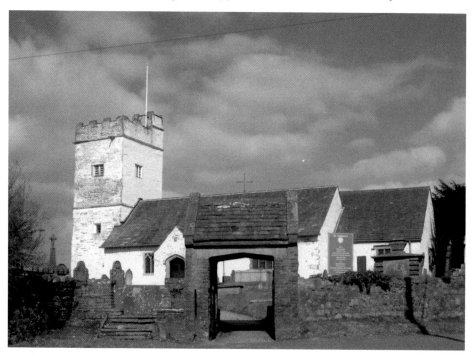

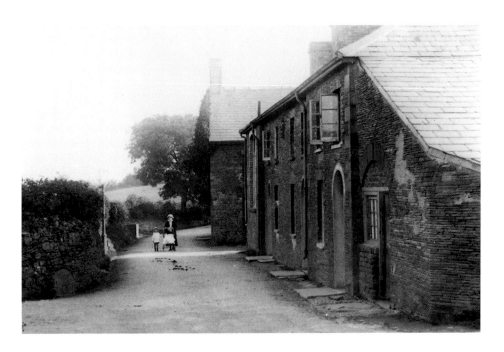

The Old Mountain Route

Since this photograph was taken a century ago, just north of where the road from Argoed meets the old mountain route from Cefn Fforest to Cefn Golau, all but one of the buildings have been demolished. The surviving house is Homelands. In Victorian times, the building on the near side of Homelands was a school, and the lean-to nearest the camera a blacksmith's shop. Between these were three cottages. New properties have been built behind the trees on the right.

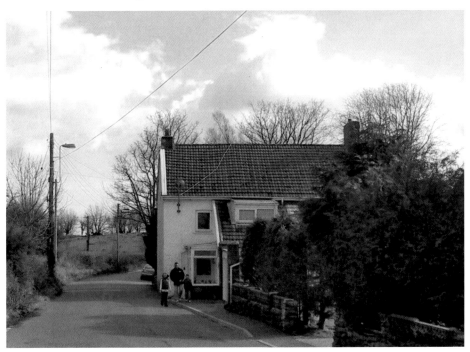

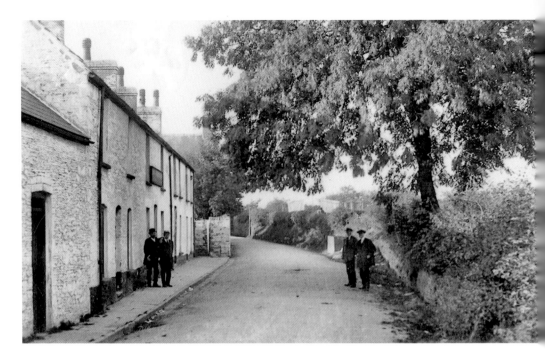

The New Inn

This is an enduring public house on the old road from Bedwellty to Tredegar. The New Inn, originally in the centre of a terrace but now incorporating the furthest cottage, was so-named because the Church Inn, situated nearer the church, is much older.

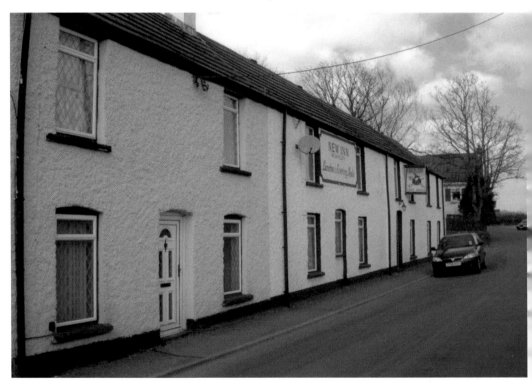

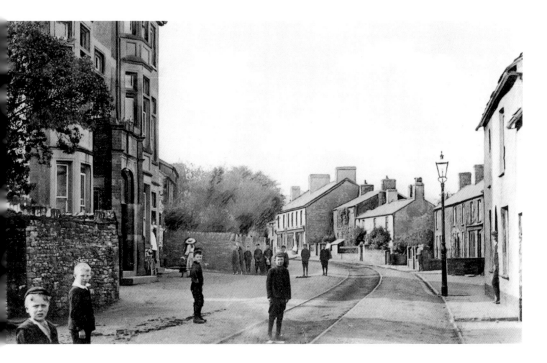

Argoed High Street

This photograph of Argoed High Street, taken before the 1920s, shows the tram road. Argoed evolved around this road, and the rails are still beneath the road's surface. On the left is the Argoed Arms, a hotel, and halfway along on the right we find the premises of the Midland Bank, adjacent to which was the Post Office. Progress dictates that neither service is now available.

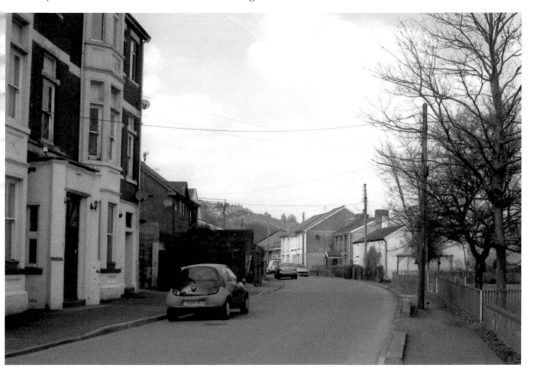

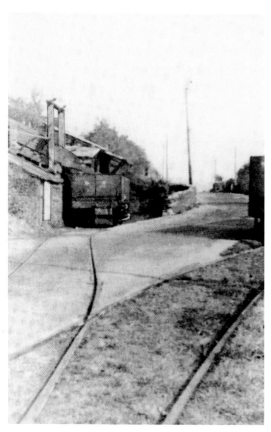

The Rock Colliery
From the middle of the nineteenth century until the mid 1940s, coal was mined at the Rock Colliery, near this bend in the main road. It is just above the site of Chris Waite's second-hand car dealership. The trucks, when loaded, would cross the main road to begin their journey to Newport.

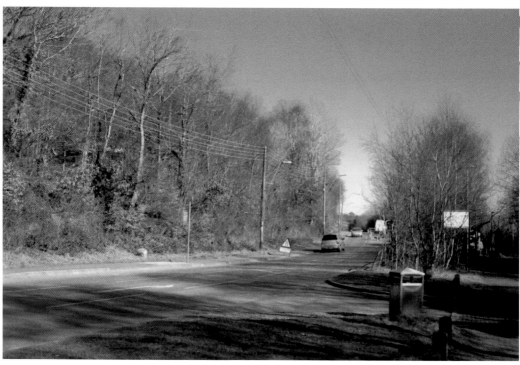

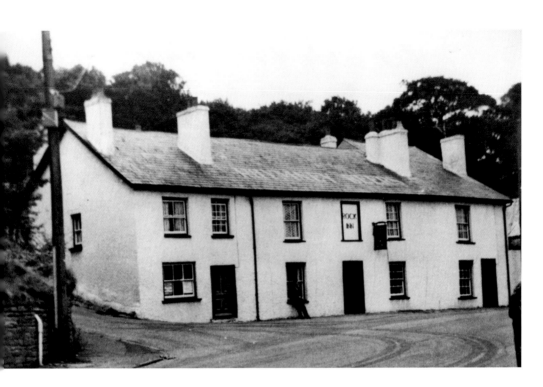

The Rock Tavern

Just north of Blackwood, this is one of the oldest continuously functioning public houses in the valley. In the eighteenth century, it was one of only eight places in the county of Monmouthshire where people could vote at election time. The local magistrates' court was also held here. Expanding to absorb the cottages on both sides, The Rock now provides a high standard of food and accommodation.

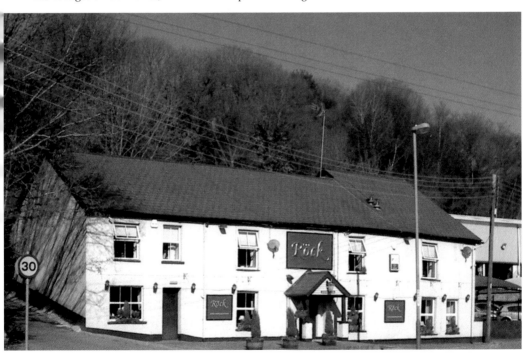

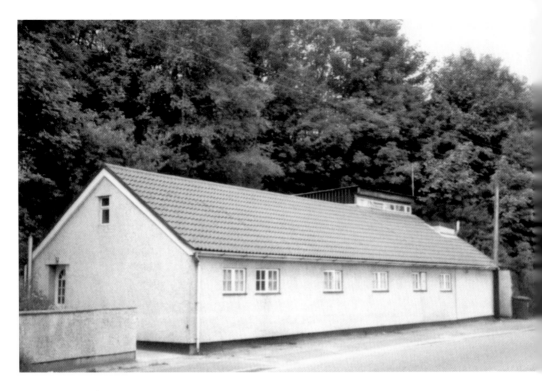

A Former Smithy

This building became residential accommodation late in the last century but now belongs to the council. The commissioned jigsaw design – a brightly coloured country scene, including bees – is the most attractive external mural in the valley.

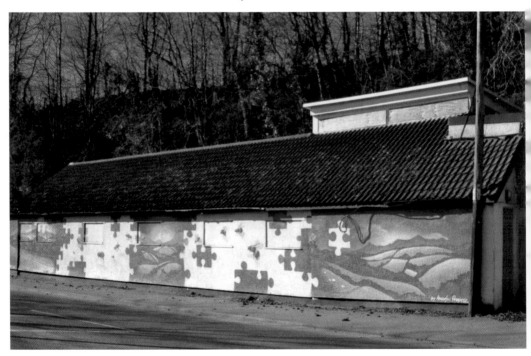

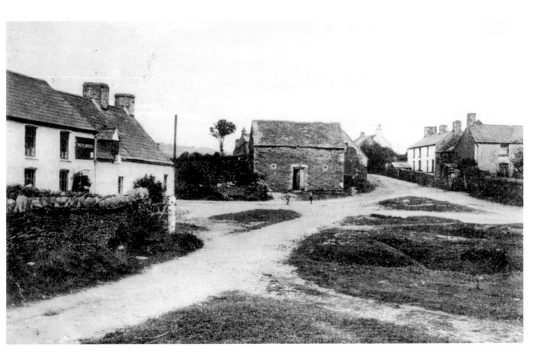

Croespenmaen, Oakdale

This is the point where five ancient tracks met. The Gwesty Inn, now a private house, stands on the left. Lady Llanover, a patron of the arts and supporter of the temperance movement, once forced the inn to become a coffee house, in an unsuccessful attempt to rid the area of the problems associated with alcohol.

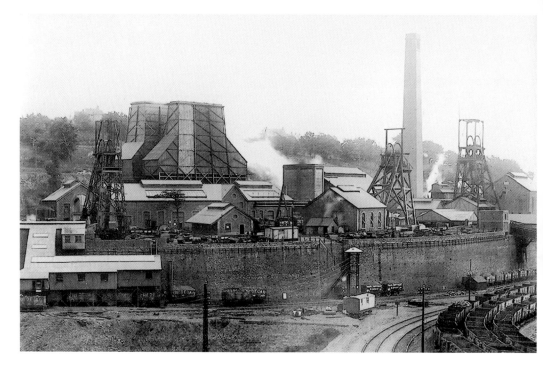

Oakdale Colliery

Opened in 1908 by a subsidiary company of the Tredegar Iron and Coal Company, Oakdale became the chief colliery in the area when Markham (1979) and Celynen North (1981) closed. Their underground workings were joined to Oakdale, which was in turn closed in 1990, concluding more than two centuries of mining in the locality. There are several new businesses on the colliery's extensive site. Three units near the western side are shown here.

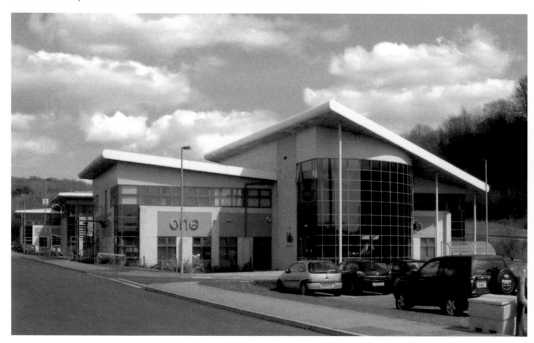

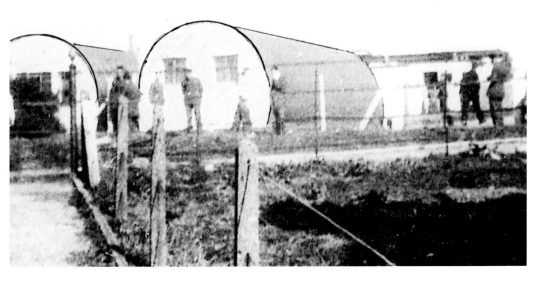

The Bevin Training Centre, Oakdale

Toward the end of 1944, there was a great demand for coal but insufficient manpower to mine it because so many young miners had joined the forces. Ernest Bevin's solution was to conscript school leavers into the mines and Oakdale became the Bevin Training Centre for Wales. The cold and draughty Nissen huts that housed them are shown here. Today, they have been replaced by these impressive detached houses.

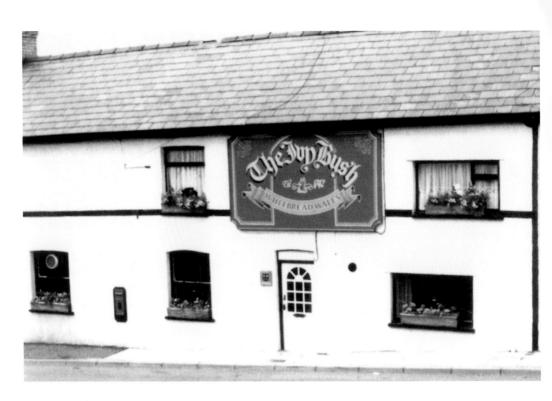

The Ivy Bush Inn

Dating from 1742, this was the only place between the Cross Oak Inn and Croespenmaen offering refreshment to travellers until the Oakdale Hotel was built *c.* 1914. For a while, The Ivy Bush functioned as The Tudor House, but it did not prosper and closed. In 2007, these high-quality houses were erected on the site.

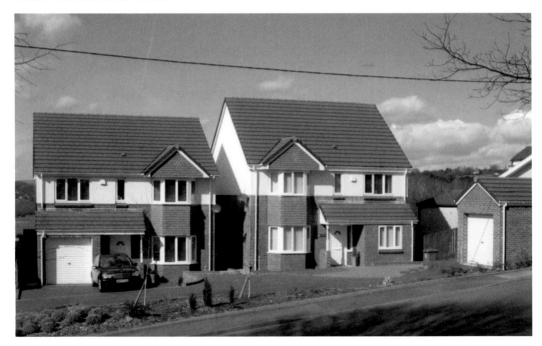

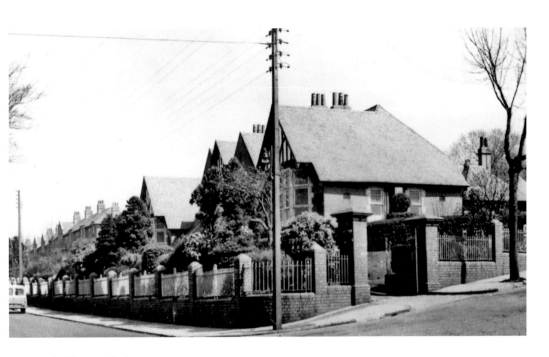

Oakdale Hospital
Opened in 1914, the hospital was needed because so many men were employed at the nearby colliery where injury was an ever-present threat. Little of its outward appearance has changed; it is still in use today.

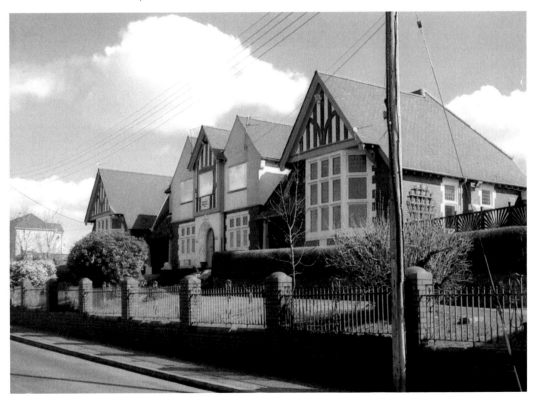

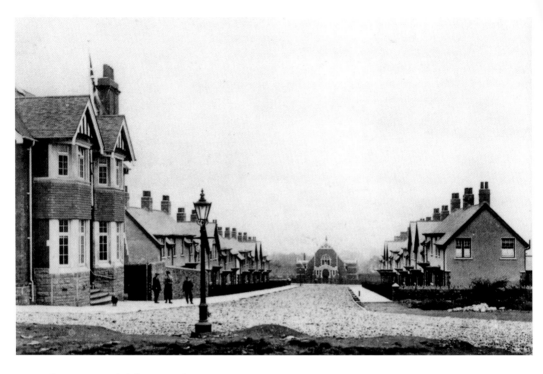

Central Avenue, Oakdale, c. 1916
This is the view before the Miners' Institute was built and the road was surfaced. Little has changed – except that the hotel, which was the base for the town band, has closed.

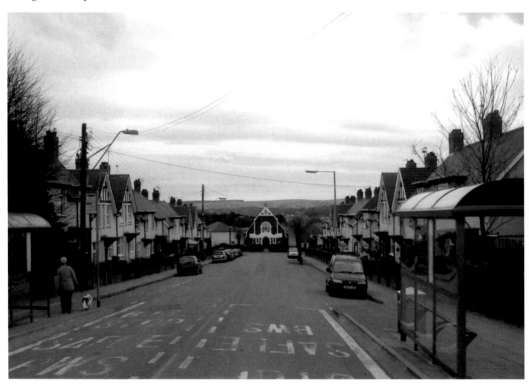

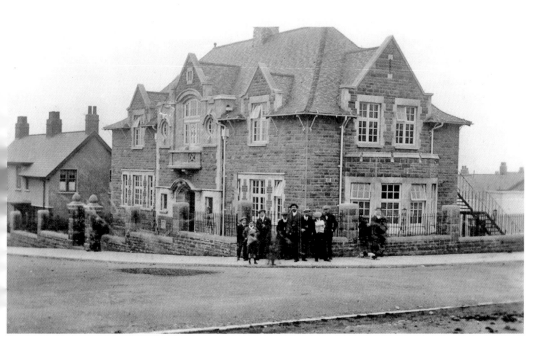

Oakdale Miners' Institute

Opened in 1917, Oakdale Miners' Institute was built using money loaned by the colliery owners and repaid by deducting contributions from every miner's pay. To its right, a large hall, which was used as a cinema, was a later addition. When the local community ceased using the building, it was taken down and rebuilt in the open-air St Fagans Natural History Museum, as a prime example of a Welsh Miners' Institute. A block of flats now occupies the site.

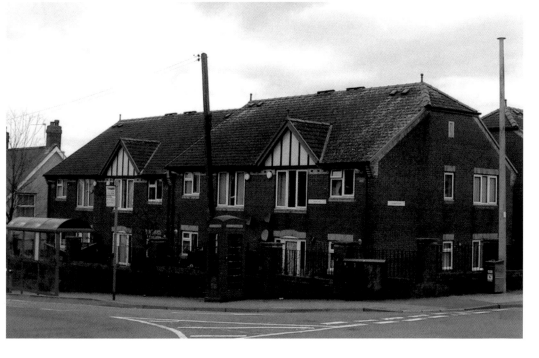

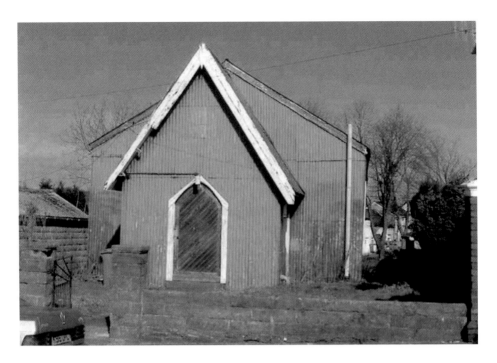

The Anglican Faithful

Anglicans who lived in Oakdale would meet in Court-y-bella, but the prosperity of the Nonconformist churches demanded a competitive building in the village itself. The solution was a timber structure covered with corrugated sheeting, imported from nearby and painted green. St David's, a modern church with a tower and a mini-spire, was built in its place.

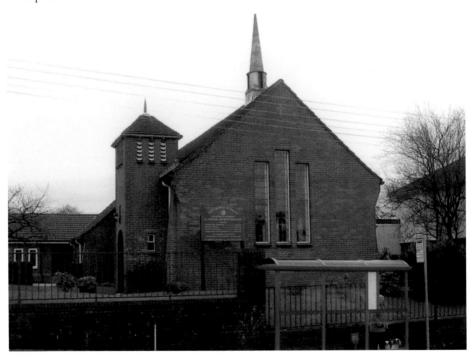

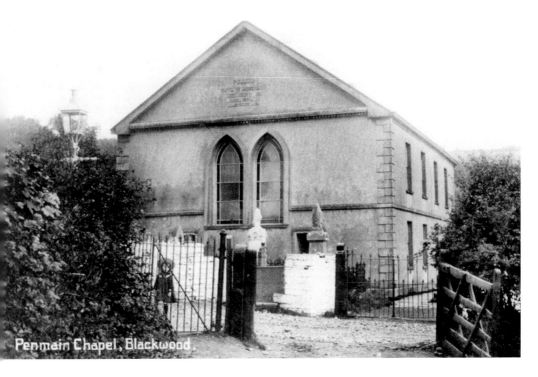

Penmain Chapel, Blackwood.

Penmaen Independent Chapel

Founded in 1639, this was the second Nonconformist church in Wales. It was completely rebuilt in 1887/88 and the last service was held in January 1990. Five members attended. Soon after closure, the building was purchased and repaired by the Mynyddislwyn Male Voice Choir, who use it as their practise hall.

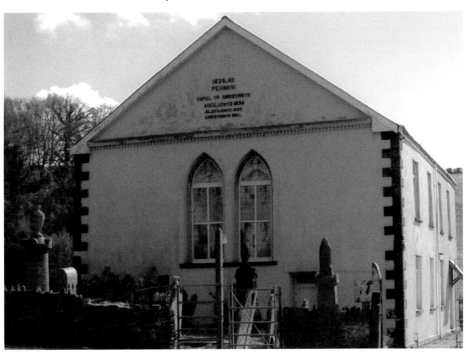

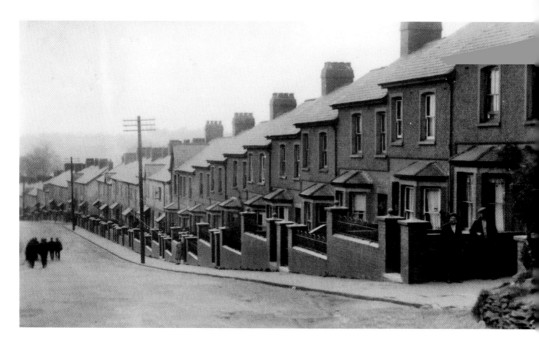

Oakdale Terrace, Penmaen, Viewed from the North
These photographs were taken from outside The Cross Oak. The earlier picture shows unwashed miners wending their way homeward on foot. The former Penmaen Chapel is out of shot to the left.

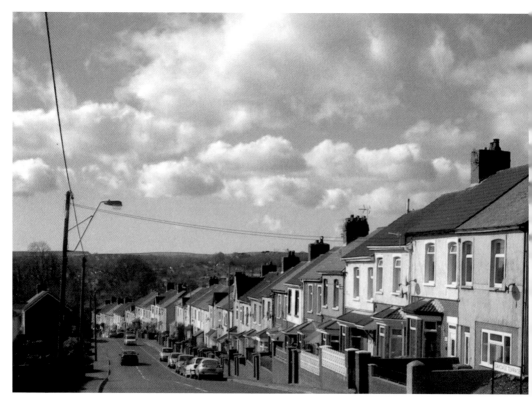

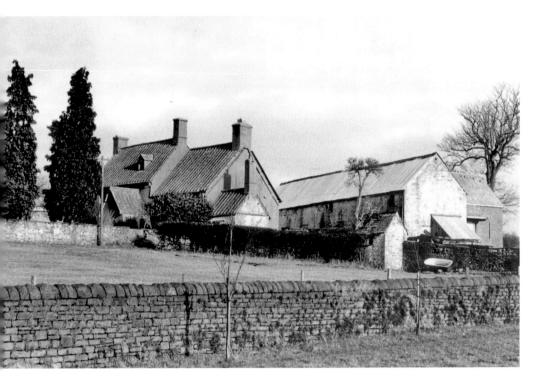

Cwm Gelli Farm

Although locals know this farm as Cwm Gelli, it is variously shown on old maps as Gellidewyll, GellyDowill, and Gellidowilt. It is one of the oldest properties in the Blackwood area, dating from *c.* 1600. The kitchen hearth was so large one could stand in it and see the sky. Yellow-washed and totally modernised, it now provides superior accommodation.

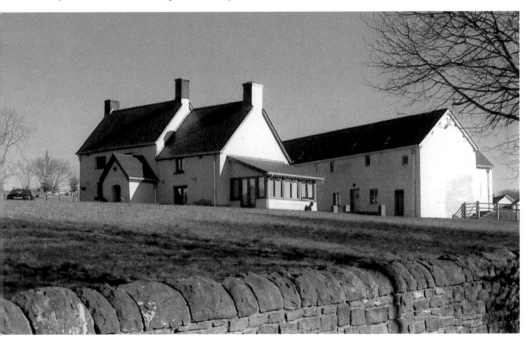

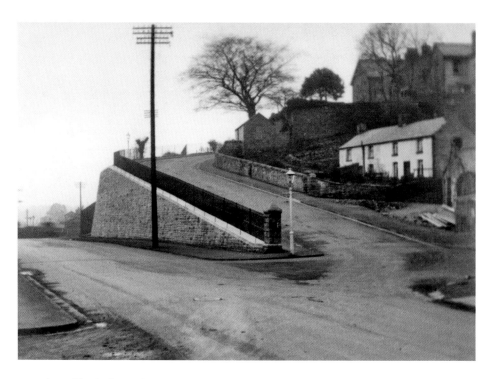

Foundry Hill, Blackwood

This is the north entrance to Blackwood, so-named because of the foundry, which was established in 1823 just to the right of the photograph. Blackwood Railway Station is visible in the distance. Today, the railings have been replaced and a bungalow has displaced the cottages. From the top of the hill there are commanding views over the valley, taking in its new Chartist Bridge and a statue of a Chartist, which gleams in the sun.

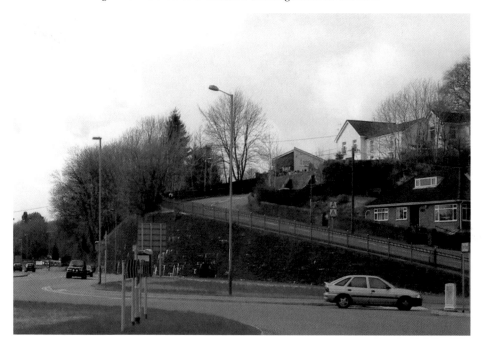

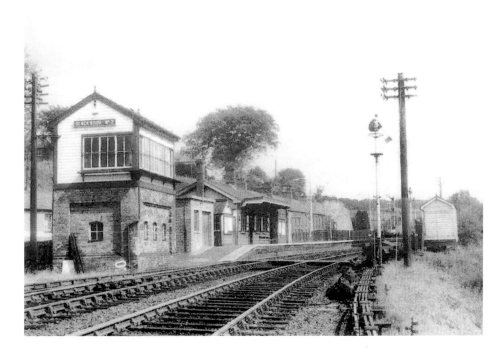

Blackwood Railway Station

This is how the station looked in the 1950s. The building behind the signal box is The Carpenters Arms, which dates from the first half of the nineteenth century. All these buildings – the station, the terrace of cottages, and the public house – were taken down to widen the main road and build the road that leads to the new Chartist Bridge, now the most striking structure in the valley. Using this single-pier cantilever bridge as a bypass has greatly eased the flow of traffic in the area.

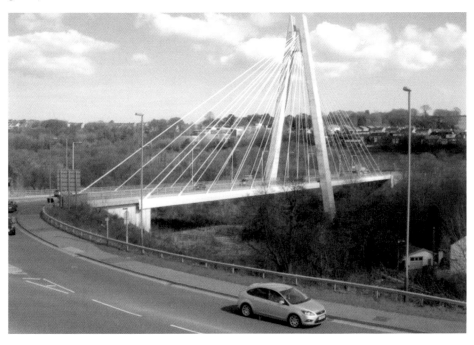

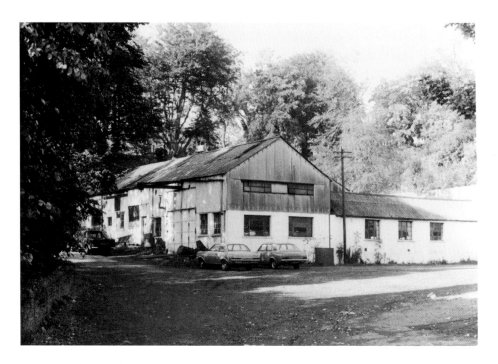

Tom Brown's Foundry

From Gibbon Tool Hire, which trades on the ground adjacent to St Margaret's Church, it is possible for builders and DIY enthusiasts to hire almost anything they need. First established as Tom Brown's Foundry *c.* 1913, it was later bought and continued as a foundry until the 1980s. The area between the buildings and the main road was once a quarry. It was filled with household refuse, covered with tarmac, and used for parking the council's buses until they moved to Woodfieldside.

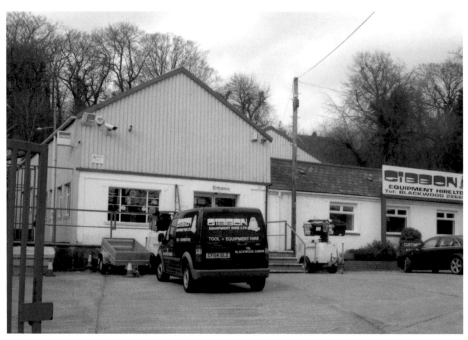

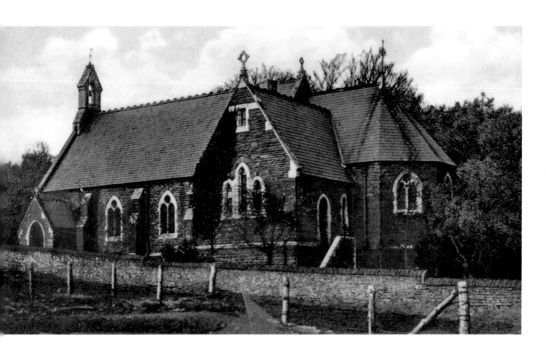

St Margaret's Church, Blackwood

Dedicated to St Margaret of Antioch, the church was built in 1876 and extended in 1891. A choir vestry was added in 1960. The lower photograph shows the parish hall, erected in the 1970s to replace the original one in Hall Street. The 'new' hall was recently modernised with help from the Lottery Fund.

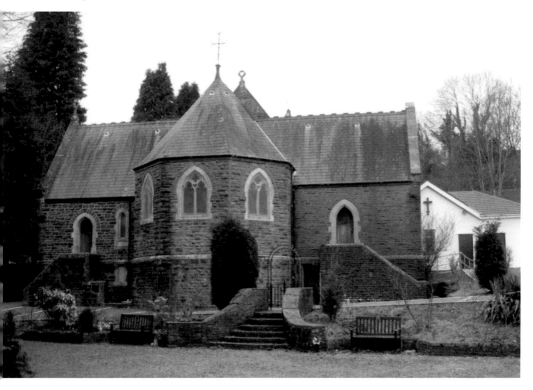

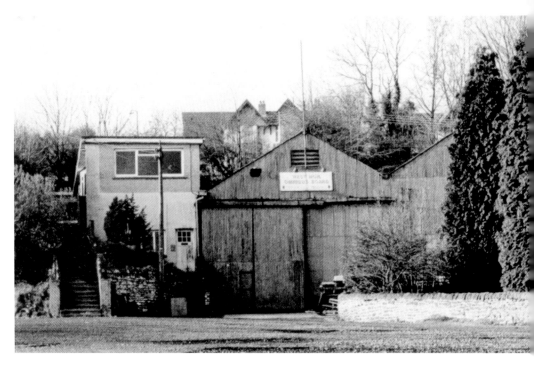

The West Monmouthshire Omnibus Board

Formed in 1926 and operated jointly by the councils of Bedwellty and Mynyddislwyn, the West Monmouthshire Omnibus Board had its home here. The company changed its name in 1974, becoming Islwyn Borough Transport, and moved to Woodfieldside in 1982. It was deregulated in 1986. The site is now an Aldi supermarket.

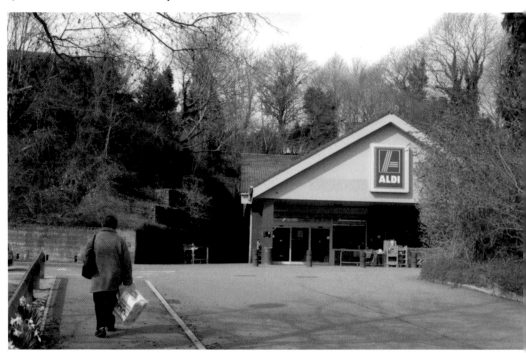

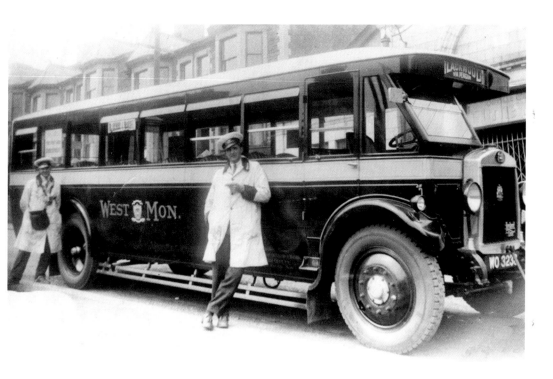

Bussing through Blackwood

This West Mon single-decker, with a driver, a conductor, and a handle for starting the engine, operated between Blackwood and Bargoed. The modern Islwyn Borough Transport single-decker, in which the driver takes the fare and issues a ticket, is shown here standing at a bay in Blackwood Bus Station.

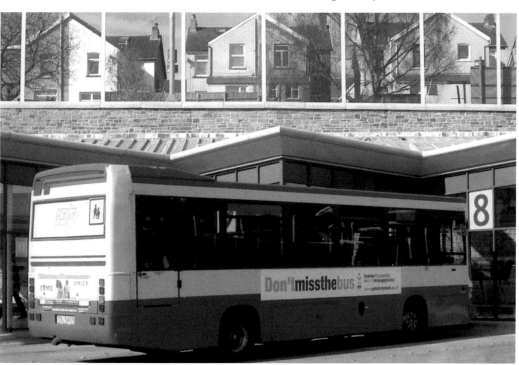

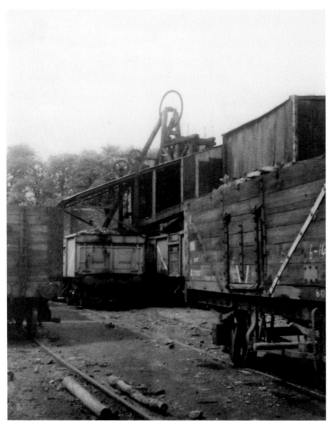

Budd's New Rock Colliery
Aldi's car park was once the site of Budd's New Rock Colliery, a small deep mine that employed at most seventy men. They mined house gas and industrial coal. The first two agricultural shows staged by Bedwellty Agricultural Society were held on this site. Before Aldi took over the ground, it had been used for many years as a park for buses belonging to the West Monmouthshire Omnibus Company.

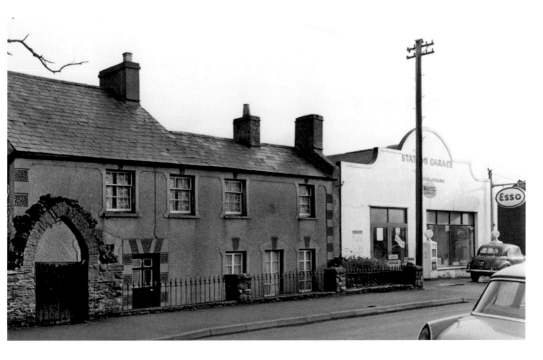

The Station Garage, Blackwood

Motor trader Harold Richardson once occupied the building on the right. It has now been converted into a branch of Homestyle, and carries carpets, floor coverings, and other household goods. When the garage was in business, diesel was 4s 3d (21p) per gallon; today a gallon is about £5.30. In place of the old houses, a pizza takeaway has appeared with a large car park at its side.

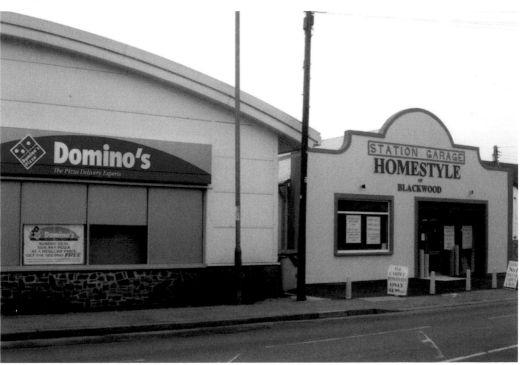

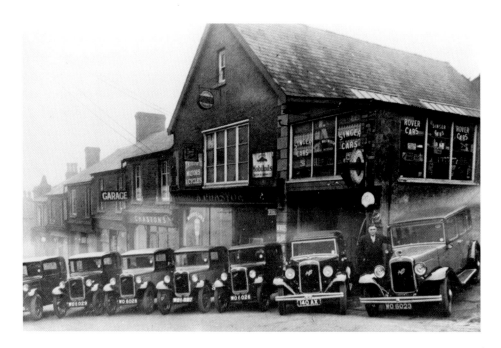

Chaston's Garage, Blackwood

Alfred Chaston came to Blackwood as a plumber but had the foresight to realise that he would do much better selling and maintaining motorcars. He set up business on Pentwyn Road and is shown here with a selection of the cars he offered for sale. Note the petrol pump immediately behind him – a position that would not be countenanced today. In place of the garage we now have two takeaways and Tydfil Training Centre.

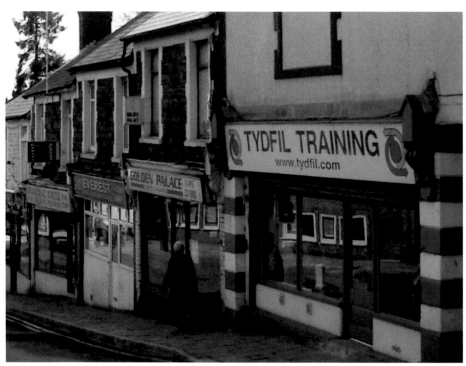

Pentwyn Road, Blackwood, c. 1930
Eighty years separate these two photographs, but surprisingly little has changed. In the intervening years, a detached house, enlarged into a double-fronted house, has been built on the only available plot.

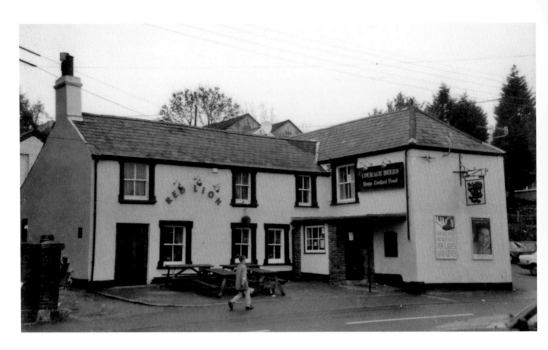

The Red Lion, Blackwood

Blackwood used to have more than a dozen licensed premises on the High Street. One of the oldest was the Red Lion. Red Lion Row was adjacent. After considerable enlargement, the building is now also licensed for live music. Red Lion Row is a car park.

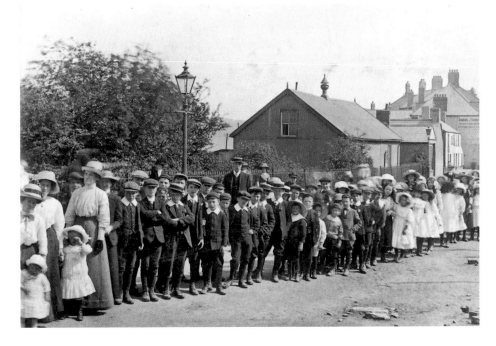

A Whitsun Walk

Boys and girls in the 1920s made sure to dress in their Sunday best before setting off on a Whitsun Walk. Everybody wears a hat or a cap. They have assembled at the bottom of Pentwyn Road, which was yet to be surfaced. The furthest building is the Midland Bank, now HSBC. Barclays Bank was some years away. The low house, end-on to the road, is still there, but all the other buildings on the east side of the High Street are modern.

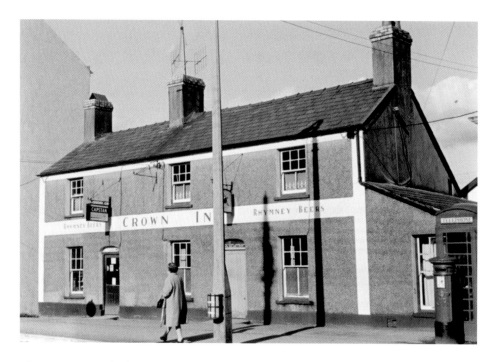

The Crown Inn, Blackwood

The QS clothing and homewear store, formerly Tesco's Blackwood base, stands on the site of two businesses: the newsagents at the far end, and the Crown Inn nearer the camera. Upon the death of the owner, the newsagents passed to other family members and was renamed Rowlands. When the site was required for development, the business moved across the street to the former premises of Cromwell Jones, a grocer who also sold wine and spirits.

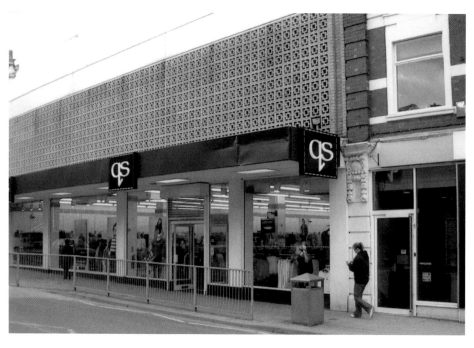

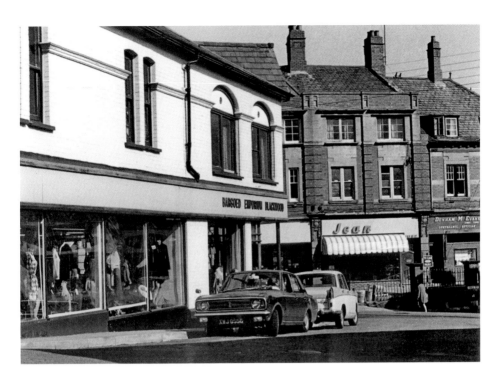

The Bargoed Emporium, Blackwood

Known previously as Powell & Jones and later Davies & Beynon, the Bargoed Emporium was destroyed by fire in 1987, after it had become H.W. Stevens Value. All these businesses dealt in drapery, ladies' wear, and household goods. The ground lay vacant until Argos came to town and established their catalogue business there.

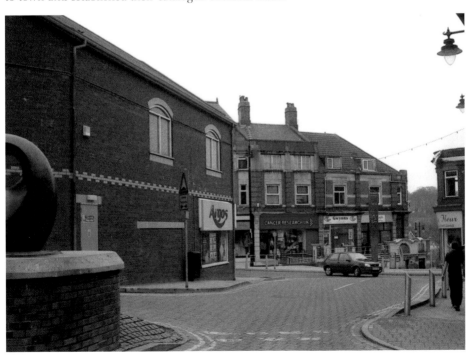

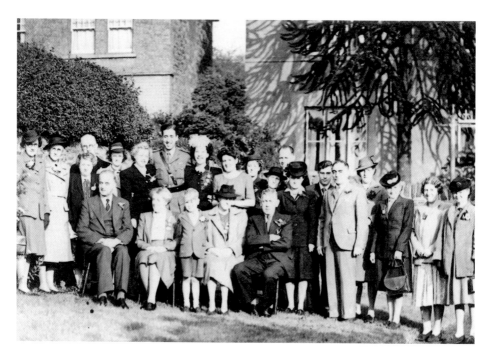

Two Weddings

The Second World War has just ended and a soldier marries his fiancée from the Sirhowy Valley. Times are difficult, so the reception is at home. And those faces; they do not exude the happiness normally associated with a wedding. Contrast this with the modern photograph. It is a far more lavish affair. Everyone is obviously in high spirits.

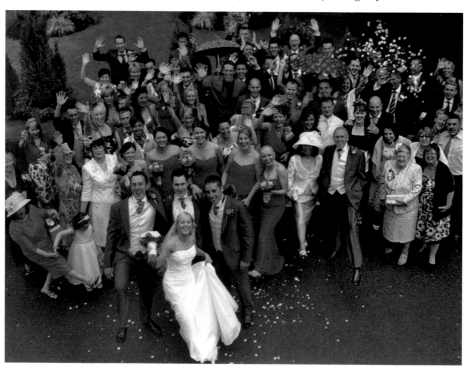

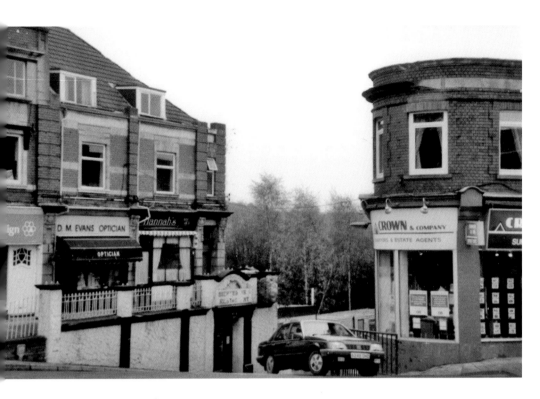

The Square, Blackwood

This car is joining the High Street from Hall Street, a manoeuvre impossible today because the street has been blocked off. In the 1830s, Hall Street was the main thoroughfare from the river bridge to Bedwellty.

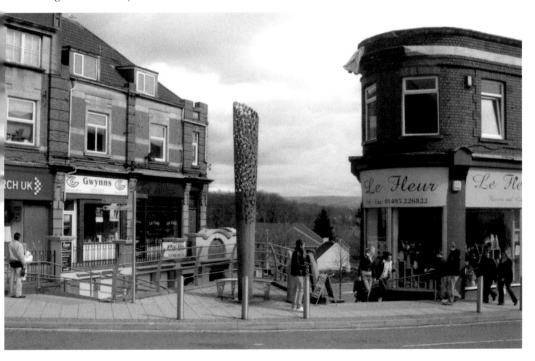

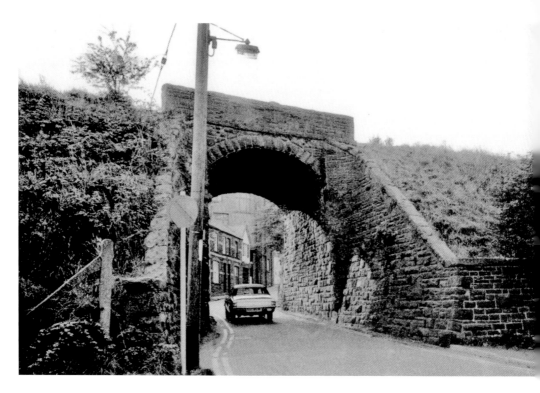

Hall Street, Blackwood

Here, we are looking towards The Square. This narrow bridge once carried passenger and mineral traffic along the valley. The original tram road passed through the High Street, but when it was decided to remove the railway to the eastern side of the High Street in 1865, several new bridges were needed. This was one of them. All the buildings, except Argos, were there long before the bridge was demolished.

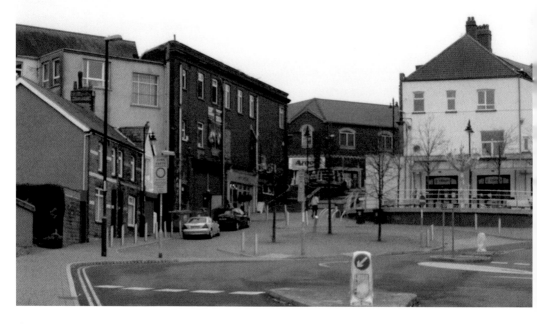

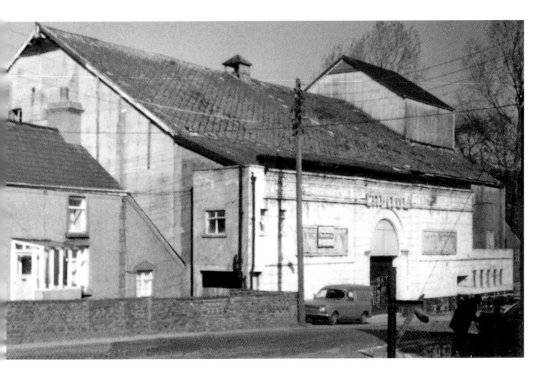

The Capitol, Blackwood

Built as an indoor market and used for live shows before it became a cinema, the Capitol suffered the fate of many cinemas after the advent of television. It lay empty for years before being demolished to make way for a Kwik Save supermarket. When this closed, it seemed a large enough location for a modern law court.

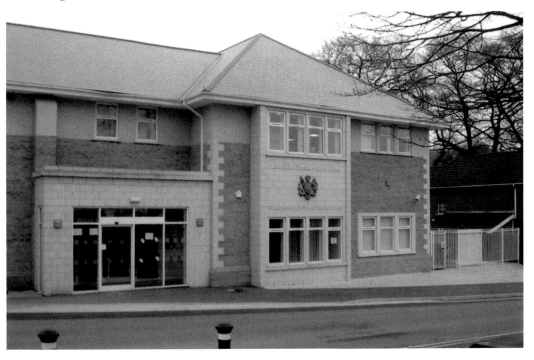

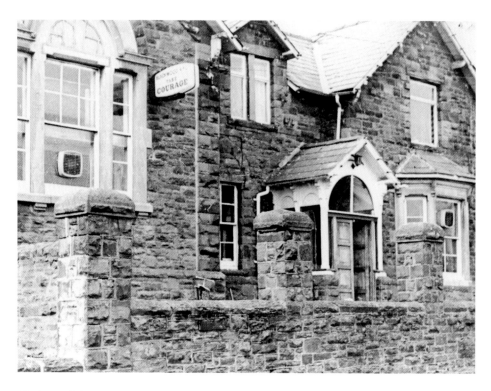

Blackwood R.F.C.

By the time this sepia photograph was taken, this building, formerly the first police station in the town, was the clubhouse for Blackwood RFC. After the rugby club built a new clubhouse in Glan-yr-Afon Park, the old building was demolished and a four-storey block of flats was erected in its place.

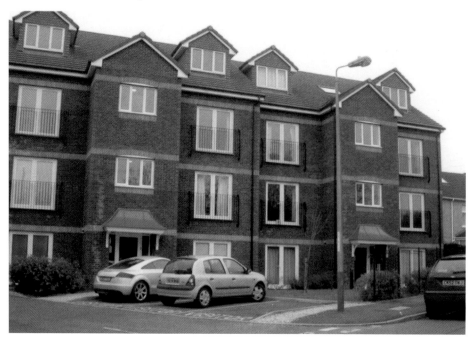

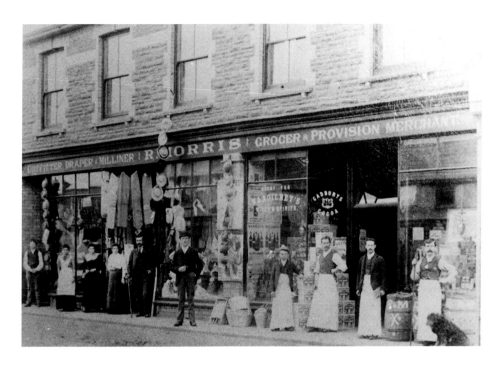

Richard Morris of Blackwood

The facia boards say it all: outfitter, draper, milliner, grocer, provision merchant. For many years, Richard Morris was one of the most important citizens in the town. Even the road up the hill at the side of the shop, now Woodbine Road, was known as Morris Lane. Subsequent to Morris, two separate businesses operate here: Tidal's Stores, which was the Woolworths of the town until the real Woolworths moved in, and Cromwell Jones' grocery, which became Rowlands the newsagent, stationer, and bookseller. The latter is now trading as Newscene.

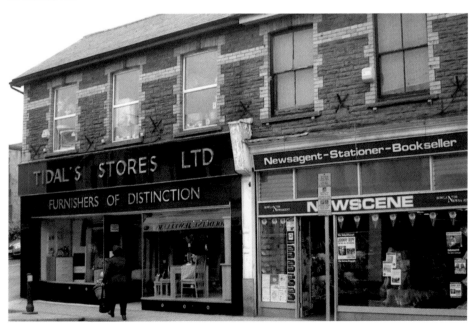

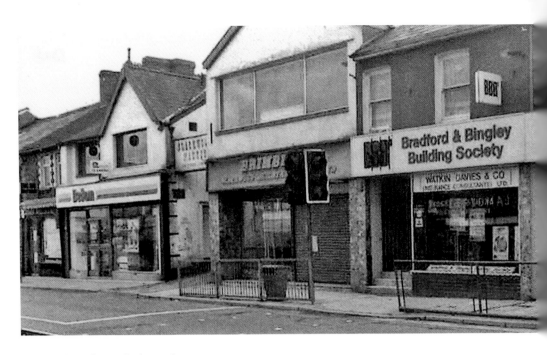

The Market Place, Blackwood

Four businesses on the west side of the High Street, namely John Williams (tobacconist), Bolom (cleaners), Brimbles (hardware and ironmongery) and the Bradford & Bingley Building Society, were demolished to make way for an entrance to the new precinct. The advent of the precinct, with its covered walkway, was well received. It links the new Market Square, where traders ply their trade on Tuesdays, Fridays, and Saturdays, with the new bus station.

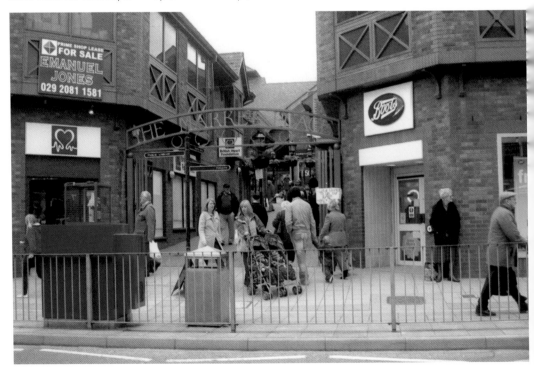

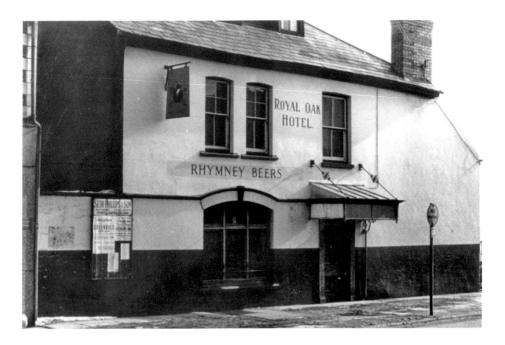

The Royal Oak Hotel, Blackwood
This is another of the town's old public houses that has disappeared. Living accommodation below street level was accessed from the side. To the right of the hotel was a large open area where markets were held from the early 1800s until the early 1950s. The open-air market moved to the new precinct. Bon Marché, a fashion store belonging to Peacocks, a company based in Cardiff, now occupies this spot.

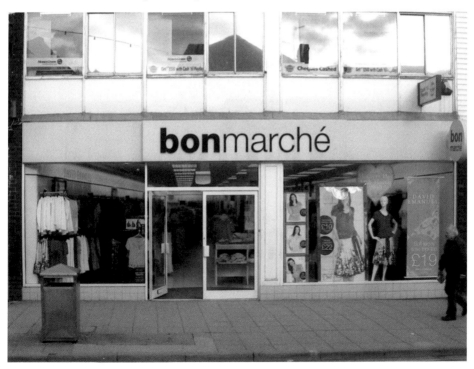

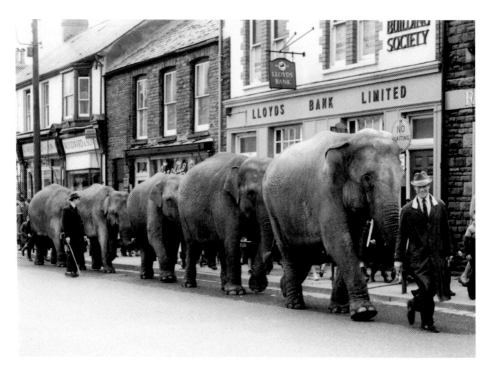

David Fossett's Circus Comes to Blackwood, 1963
This was quite a spectacle for Blackwood High Street. Five elephants are being led through the High Street to the field in front of the Masonic Hall, where the circus was based. Lloyds Bank has become Lloyds TSB and has expanded into what were once the premises of Jones the Greengrocer. The baker and butcher have also finished trading.

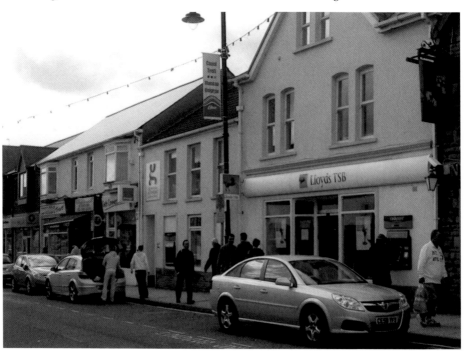

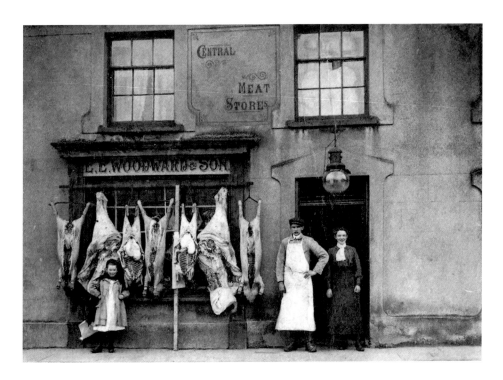

E.E Woodward & Son, Blackwood

Once upon a time, this building, dating from *c.* 1830, was the Yew Tree Inn and home of the Chartist Zephaniah Williams, but in 1854 it became a butcher's shop. In the mid-twentieth century the business expanded next door. The original butcher's shop is now a florist and the property they expanded into has become Get Connected, a mobile phone shop.

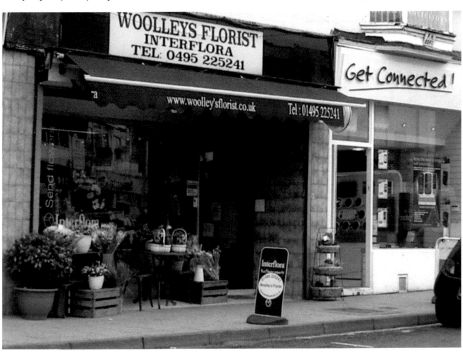

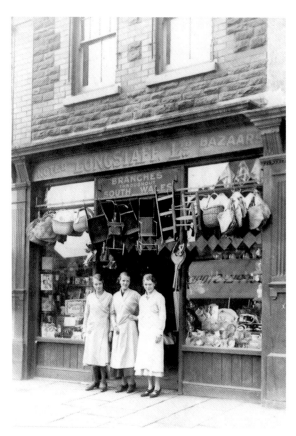

Longstaff's Noted Penny Bazaar, Blackwood

Covering many towns in south Wales, this Cardiff firm packed its shops with cheap goods. This is the Penny Bazaar's staff in the 1920s. The business closed in the 1950s and the building was converted into a butcher's shop. At present, it is a newsagent trading under the name S&K Supercigs.

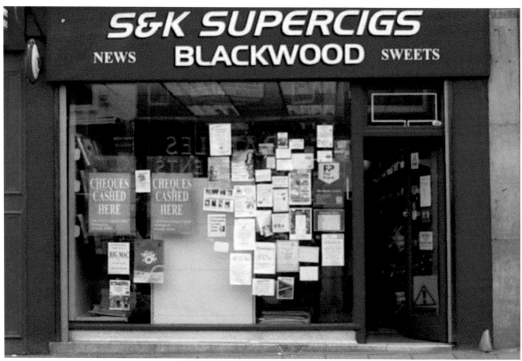

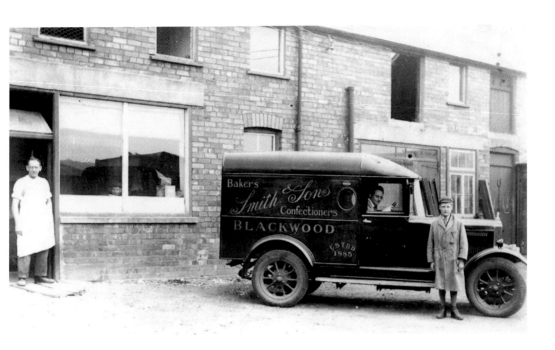

Smith & Sons, Blackwood

Once again, it is difficult to see that these two photographs were taken from the same spot. John Smith came to the town from Stonehouse, Gloucestershire, towards the end of the nineteenth century to work as a baker. With this Morris Van, Smith & Sons moved from the era of the horse and cart to that of the motor vehicle. Now, on market days, you can buy meat or have your watch repaired on this spot.

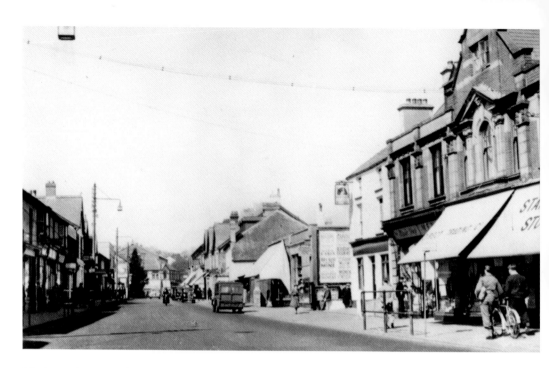

Blackwood Bus Station

At the time this photograph was taken, soon after the end of the Second World War, there was no bus station in Blackwood. Buses parked on the High Street, as can be seen from the bus stands on the sides of the road. Prospective passengers frequently caused serious congestion on the footpaths. Times have changed; Blackwood now boasts an ultra-modern, award-winning bus station.

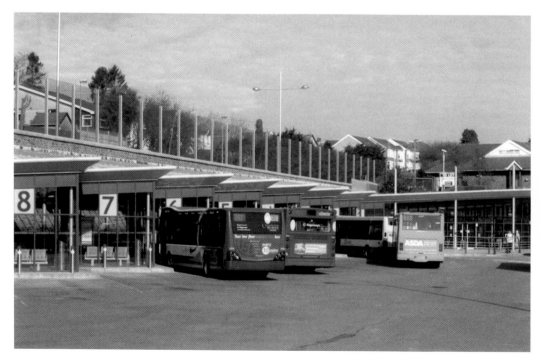

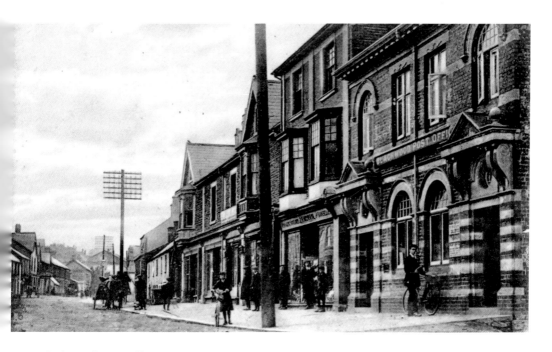

Blackwood Post Office, *c*. 1920

In the early 1920s, a Crown Office was opened in Blackwood. At this time, calls by telephone were connected manually to the relatively few subscribers, and telegrams were sent using Morse Code. When the telephone exchange moved to a separate building, a new Post Office was built on the opposite side of the road. It took over ground vacated by the removal of a terrace of cottages that were so old the privies were at the bottom of the gardens and there were no windows to their rear.

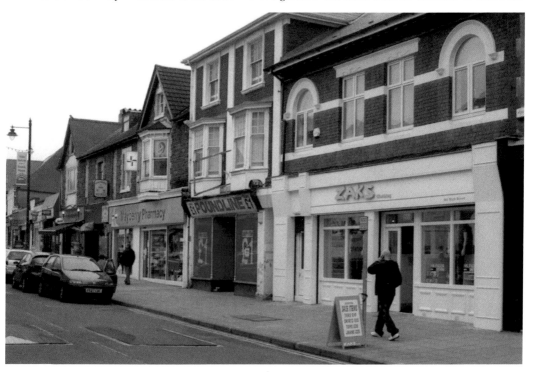

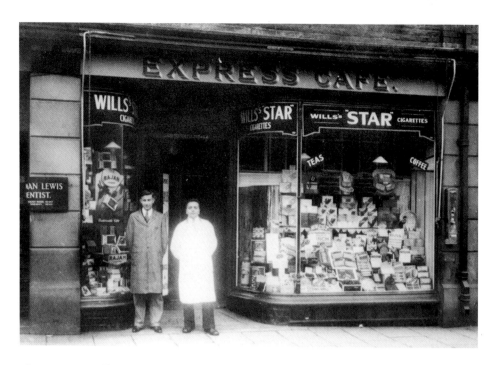

The Express Café, Blackwood

Ma and Pa Resteghini, as they were affectionately known, came to Blackwood in 1923 from the Italian town of Bardi. At the south end of the High Street they opened the West End Café. Their two sons, Vic and Pete, entered the business and soon opened their own cafés. The Express Café is shown here with Pete and his assistant. The Continental Café was opposite the Maxime Cinema. Sadly, none of the cafés survive. The grandchildren have chosen learned professions and The Express Café has become The Hair Shop.

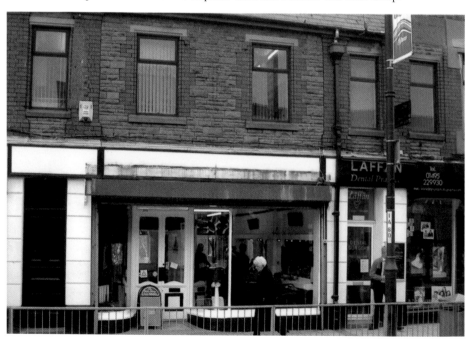

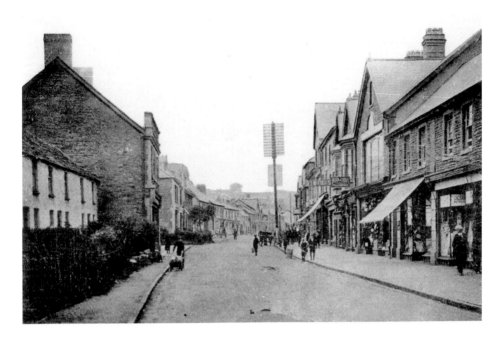

The Co-operative, Blackwood

The property on the left, projecting across the pavement, was where the Co-operative Wholesale Society had their clothing outlet. On either side was a terrace of houses. The low-ceilinged, whitewashed cottages became the site for the new Post Office. The hidden terrace and the Co-operative building were eventually replaced by a large Co-operative store that sold groceries. Subsequently, the Co-op built their Pioneer supermarket (now Sainsbury's) in Pontllanfraith. Wilkinson has taken over the ground floor of the building; Emily's Market, which includes a café, operates upstairs.

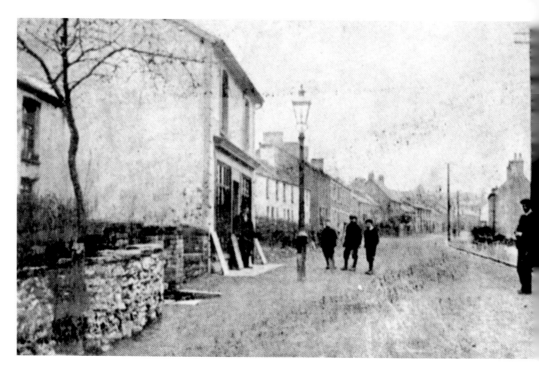

A.E. Smith's Newsagent, Blackwood
Now Linda's House, a takeaway, and Blackwood Discount Jewellers, this property was once a newsagent belonging to A.E. Smith, a prominent member of the Salvation Army. Both of the terraces beyond were demolished years ago.

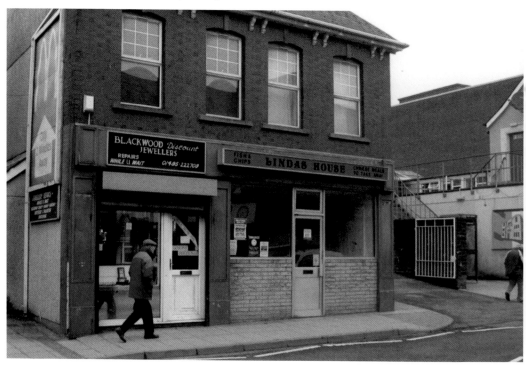

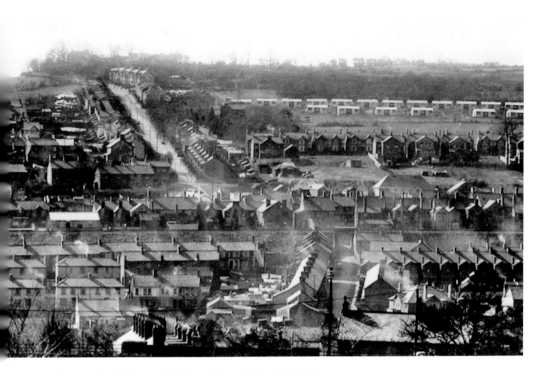

Gordon Road, Blackwood, Viewed from Woodfieldside

The older view shows the railway embankment between William Street and the High Street, and the prefabs on Albany Road. Erected soon after the last war, they were supposed to have a life of roughly twenty years. Many lasted more than twice that time.

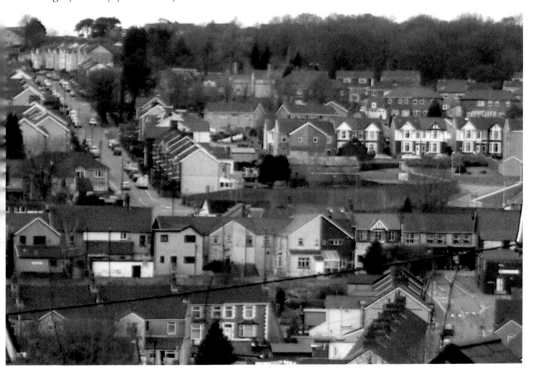

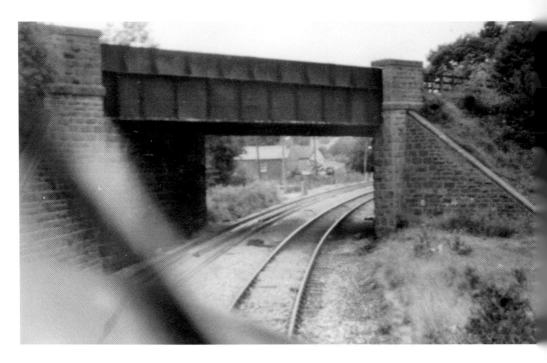

Woodfield Bridge, Blackwood, Viewed from the South

This photograph was taken from the cab of a Class 37 locomotive when there was still a railway line running along the eastern side of the valley, servicing the collieries at Markham and Oakdale. When the collieries were closed, the line became superfluous. The track and bridge were removed and a road was constructed, enabling this Audi TT to drive from Tredegar to Newbridge without driving along Blackwood High Street.

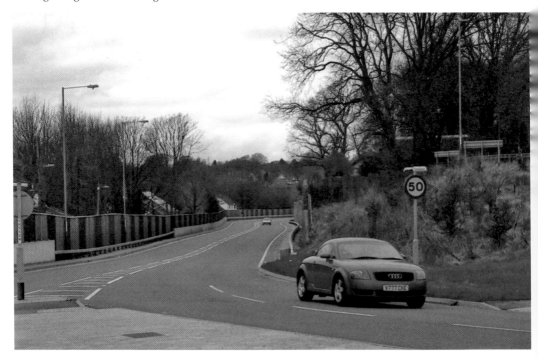

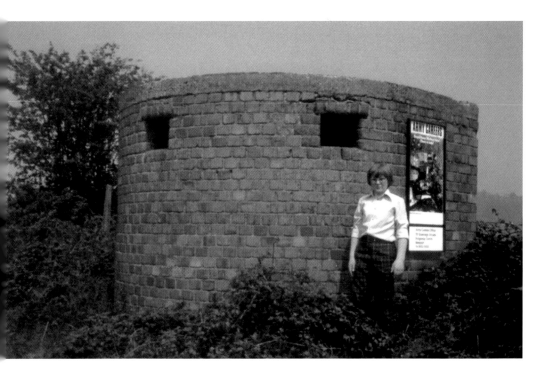

Second World War Pillbox, Pontllanfraith

Chris Sharp stands next to a Second World War pillbox on the bank to the east of the railway line that runs parallel to the road, opposite Pontllanfraith Grammar School. Thousands of pillboxes like this appeared throughout the country in anticipation of the Home Guard protecting us from the advancing enemy. When it was decided to build new council offices in the field behind the pillbox, it was removed.

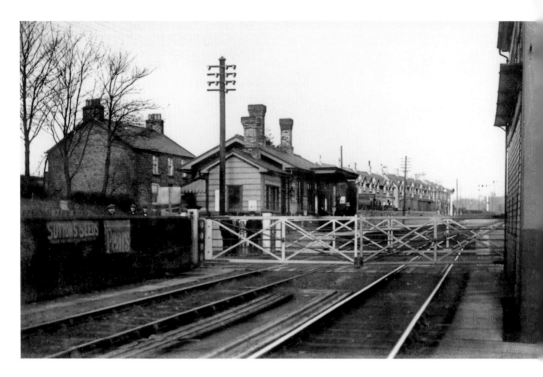

The Presbytery, Pontllanfraith

Everything in this photograph that is to do with rail transport disappeared some years ago, as is indicated by the height of the trees. The property on the left is The Presbytery, the home of the local Roman Catholic priest.

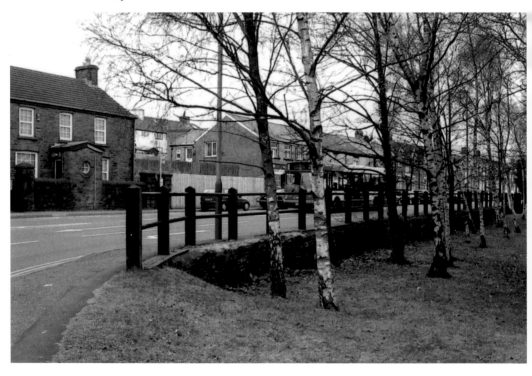

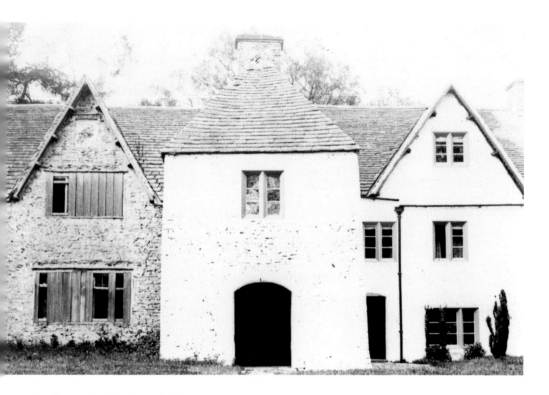

Penllwyn Sarf, Pontllanfraith, c. 1905

A two-storey sixteenth-century Tudor mansion, this beautiful old house was built by landowner Thomas Morgan of Newport for his favourite son Edmund. Penllwyn Sarf means "end of the serpent's bushes". Abandoned by the family, it suffered dilapidation as illustrated here in 1905, but is now Penllwyn Manor, a fine hotel.

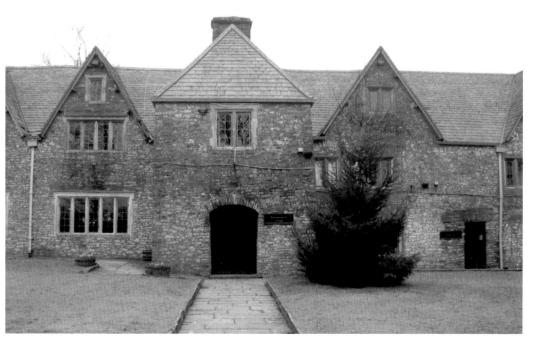

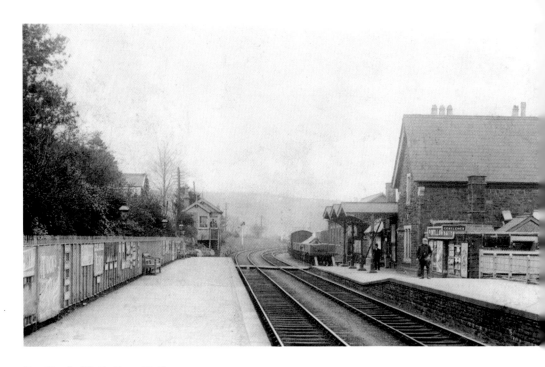

Pontllanfraith Bottom Station

On the main line linking Pontypool and Swansea, this station was where Sir Julian Hodge, the successful banker and entrepreneur, worked as a clerk. The railway line became one side of the dual carriageway. St Augustine's Church, hidden by the station buildings in the earlier photograph, has gained a large car park from the changes.

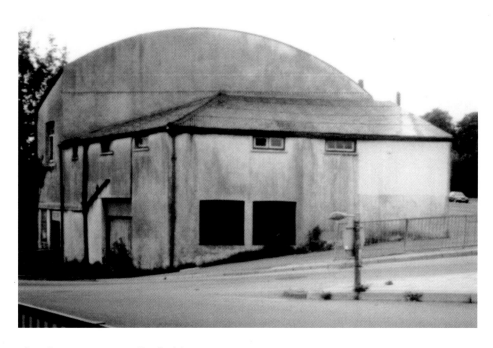

The Plaza Corner, Pontllanfraith

Unlikely as it may seem, for many this building was the social centre of Pontllanfraith. Within its walls were a function hall, where dances were held, and a billiard hall, which was a great attraction for the boys attending the technical school opposite. A block of flats with garages beneath now presents a far more appealing picture to the eye.

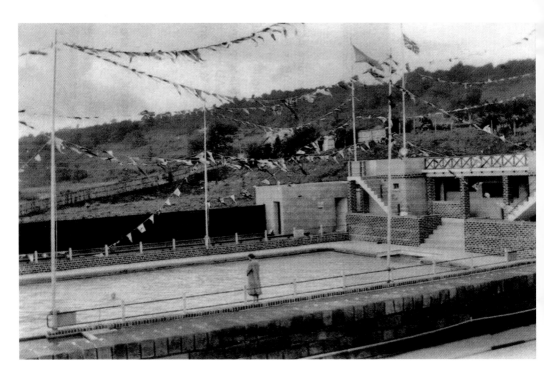

Outdoor Baths, Pontllanfraith

Built in the 1930s by the local council, the baths became very popular, particularly in the warm summer months of the years that followed. Alas, as the years passed, it was realised that the Sirhowy Valley did not get sufficient warm weather to justify the baths' retention. Indoor baths were built in Cefn Fforest, just above Blackwood, and the open-air baths were replaced by a children's playground.

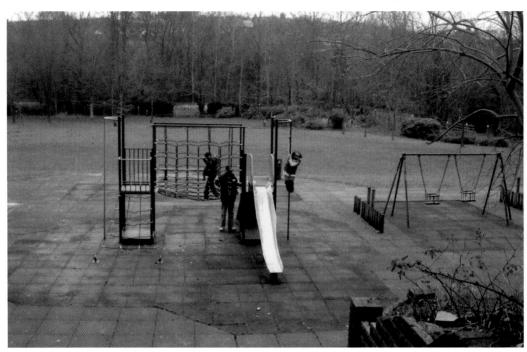

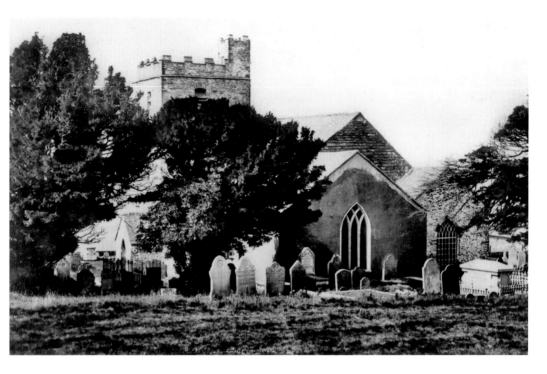

St Tudor's Church, Mynyddislwyn

The parish church for Mynyddislwyn dates from the eleventh century, but was rebuilt on a larger scale *c*. 1820, although the west tower, which is now whitewashed, was untouched. It stands in an isolated spot near the ridge of the mountain. There is little in the vicinity, apart from the Church Inn and the even more ancient Twyn Tudur, a motte. Inside the church, an amusing memorial tablet tells us that John Williams died in 17,783.

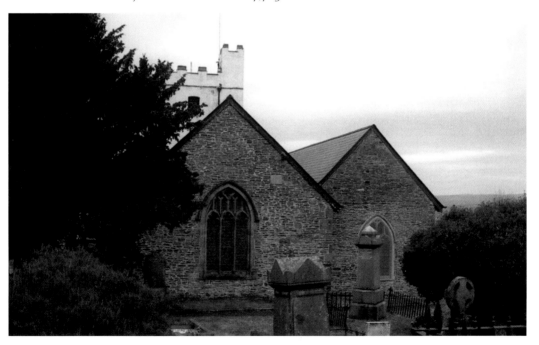

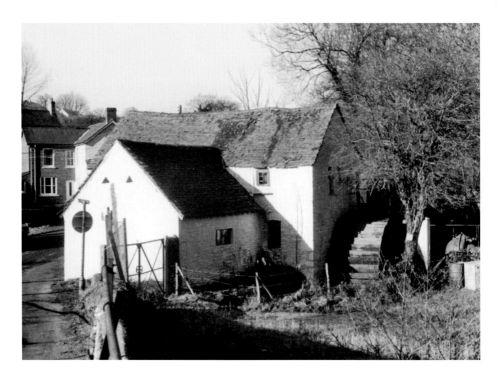

Gelligroes Corn Mill

One of the oldest industrial buildings in the area, the mill sported a twelve-foot diameter wheel some six feet wide, which was powered by water from the River Sirhowy. The Moore brothers, who owned the mill, were also fanatically interested in radio and recorded messages sent from *Titanic* when she was sinking. The nearby stables have become a candle factory, and the mill is open as a museum.

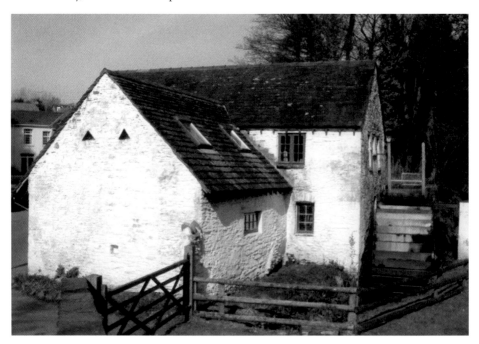

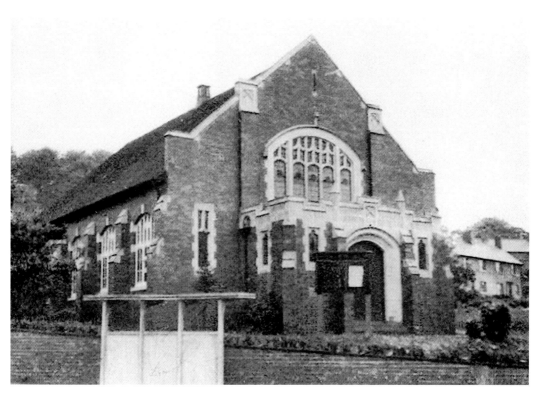

Methodist Church, Wyllie

Modelled on its mother church in Blackwood, this Methodist Church dates from 1928. Due to a decreasing membership, it ceased to function and was taken down in the early 1990s to be replaced by Marion Jones Court, living accommodation named after the local nurse.

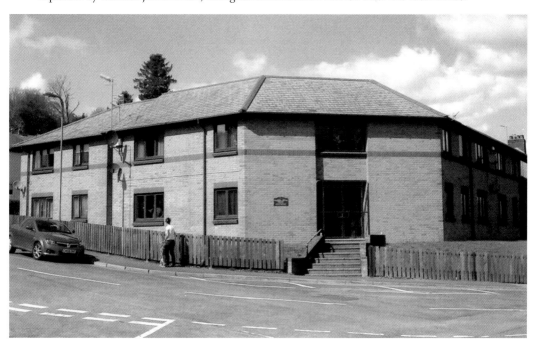

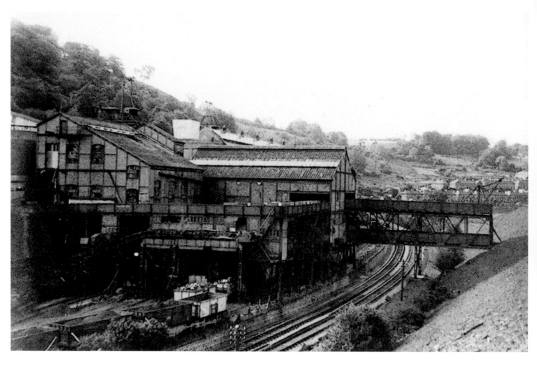

Wyllie Colliery
Named after Lt-Col. Alexander Wyllie, the colliery was opened in 1926 and closed in 1967/68. The modern photograph shows some of the superior new properties at the former site of the colliery baths, which served the miners from 1949 until the colliery closed.

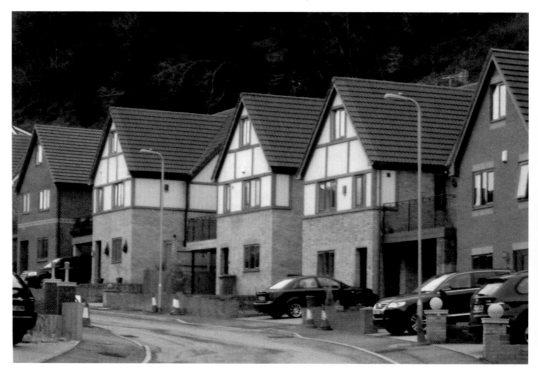

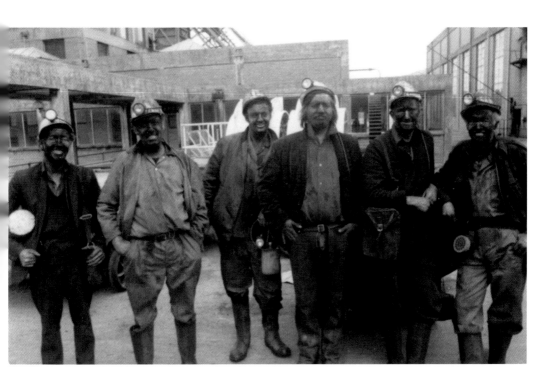

Working Conditions in the Valley

Contrast these six local miners going to the baths at the end of a shift in 1986 with a group of factory workers at Penny & Giles, Nine Mile Point Industrial Park, in 2010. The pictures illustrate how much working conditions have improved for the men of the valley since the era when seventy per cent of the male population worked in the collieries.

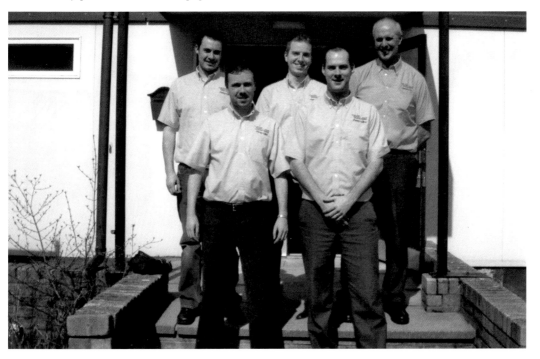

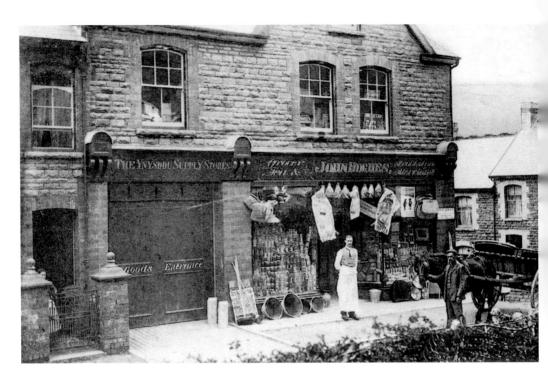

The Ynsddu Supply Stores

This property in Ynysddu, belonging to John Hughes, was the principle supply stores for Ynysddu and Cwmfelinfach before the shops on Maindee Road, Cwmfelinfach, were up and running. As a result of the new businesses, John's declined and eventually closed. For decades, the old store has functioned as the Progressive Club.

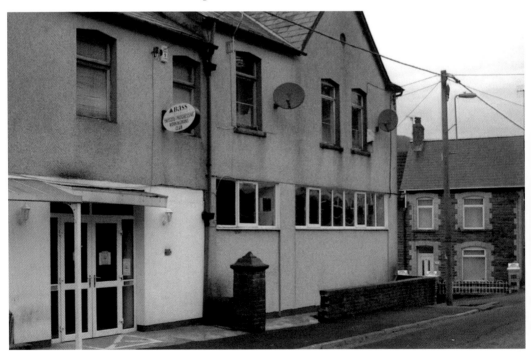

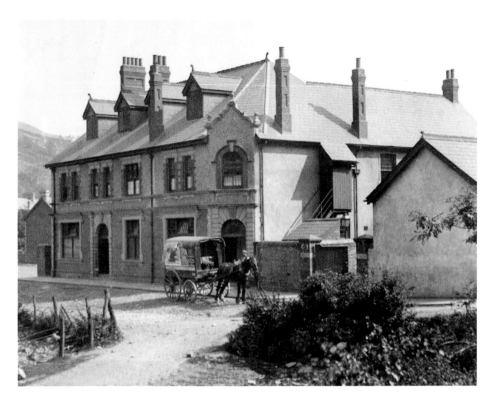

The Station Hotel, Ynsddu

In the days of the horse and cart, what is now the Ynsddu Hotel stood between the many terraces and the era's principle mode of transport, the railway. Still on the periphery of the village, the hotel continues to thrive.

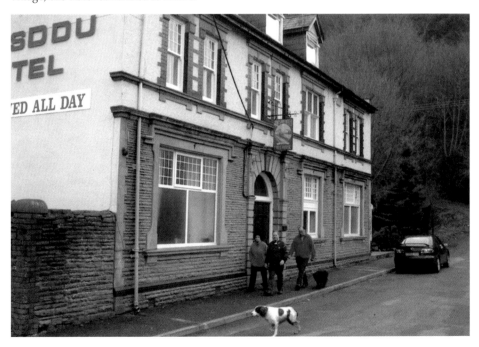

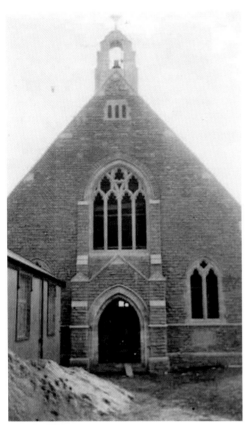

St Theodore's Church, Ynysddu
Built in 1926 to replace the Mission Church, which dated from 1905, St Theodore's is roughly halfway between Ynysddu and Cwmfelinfach, and was built to serve both villages. The church organ is interesting, for it is believed to have started life at Sandringham, the royal estate in Norfolk. The Mission Church, a timber structure covered with corrugated sheeting, became the Church Hall but was destroyed by fire *c.* 1988.

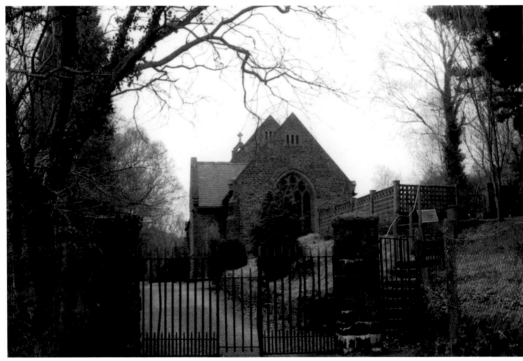

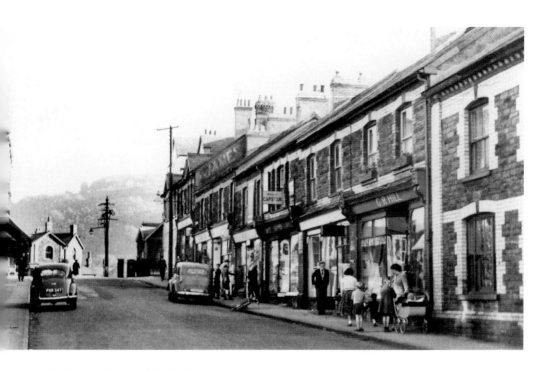

Maindee Road, Cwmfelinfach

These shops were once part of a thriving shopping area. There were once five butchers in Cwmfelinfach, but now there are none. These photographs illustrate what has happened in villages throughout the land. Local shops have vanished. Everyone must now journey to a supermarket.

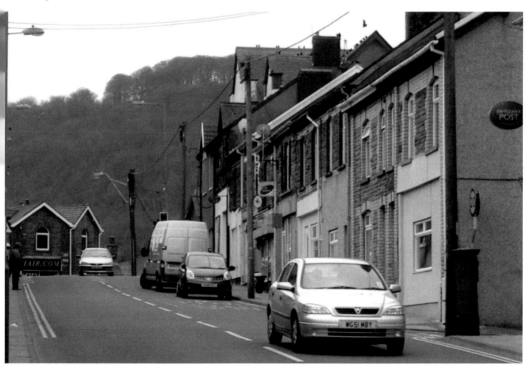

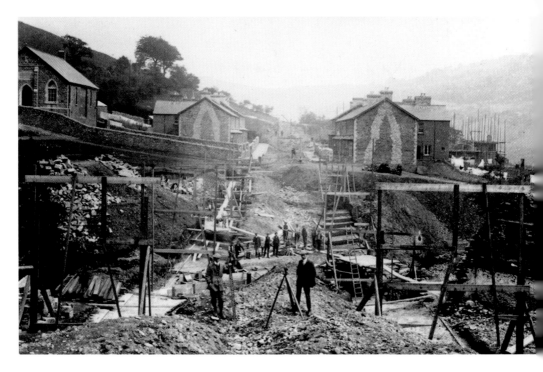

The Road to Newport

Taken in Cwmfelinfach before the First World War, this photograph shows the construction of a bridge over the stream, in order to redirect the main road to Newport. In the period between the taking of the two pictures, the Nine Mile Point Miners' Institute was built and taken down.

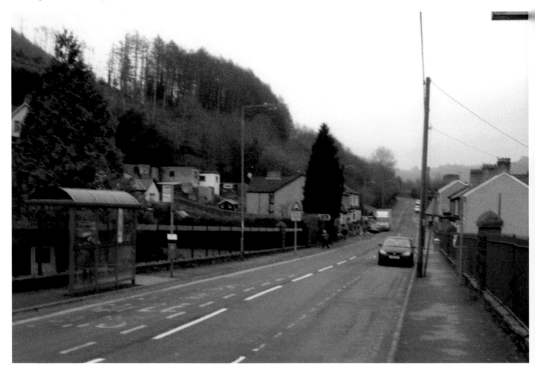

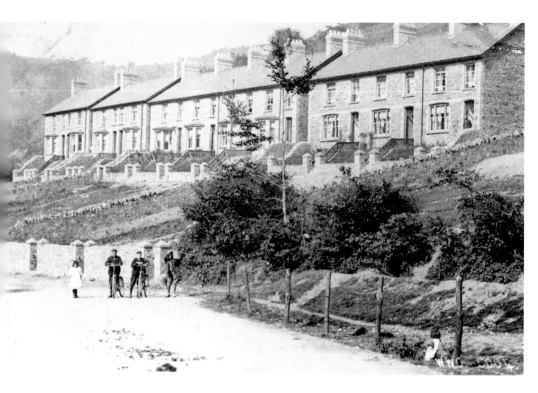

Hafod Tudor Terrace, Wattsville

Several new houses have been added in the space between the original terrace and the main valley road. Out of shot to the left is The White House, a care home on Troed-y-Rhiw Road.

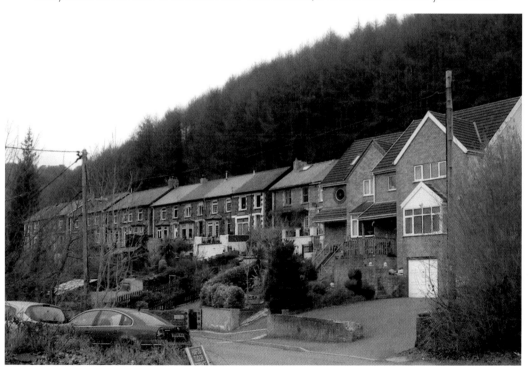

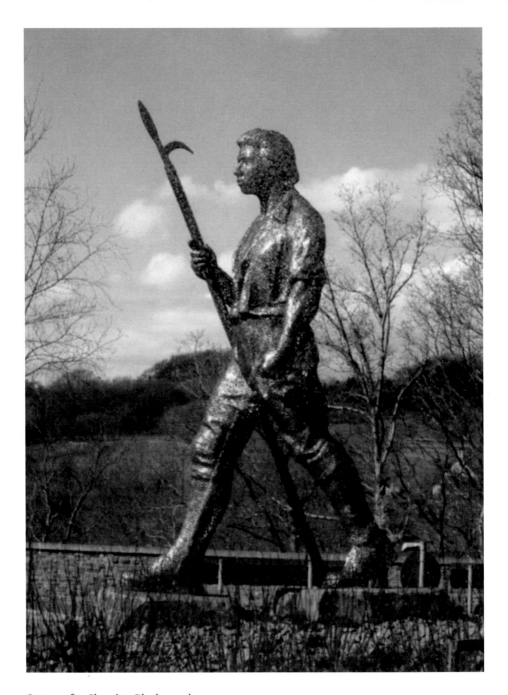

Statue of a Chartist, Blackwood

This iconic statue stands on the roundabout at the eastern end of the Chartist Bridge. A pike-wielding Chartist, he represents those who joined the march from the Sirhowy Valley to Newport in 1837, after which twenty-two Chartists met their end during a confrontation with soldiers at the Westgate Hotel. The *People's Charter* demanded six things: universal suffrage, the ballot, annual parliaments, payment for MPs, equally weighted constituencies, and the abolition of property qualifications. We may not have all of these, but we have come a long way.